TOM WOLFE CARVES...
A Horse of a Different Color

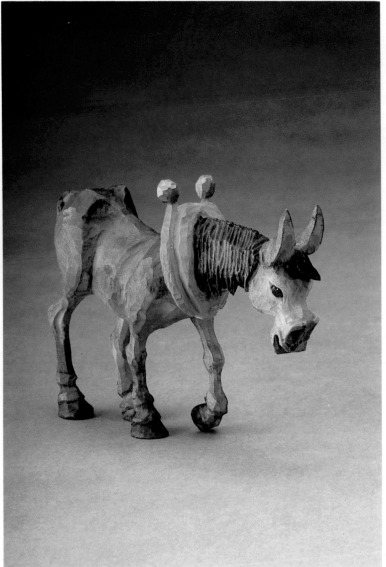

Text written with
and photography by
Douglas Congdon-Martin

Schiffer Publishing Ltd

77 Lower Valley Road, Atglen, PA 19310

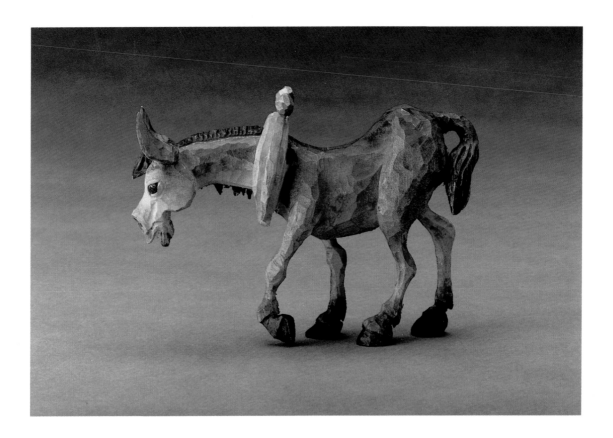

Printed in the China
ISBN: 0-88740-787-0

We are interested in hearing from authors
with book ideas on related subjects.

Library of Congress Cataloging-in-Publication Data

Wolfe, Tom (Tom Jones)
 Tom Wolfe carves--A horse of a different color / text written with and photography by Douglas Congdon-Martin
 p. cm.
 ISBN: 0-88740-787-0 (soft)
 1. Wood-carving. 2. Horses--Caricatures and cartoons. 3. Horses in art. I. Congdon-Martin, Douglas. II. Title. III. Title: A Horse of a different color.
TT199.W65 1995
731'.832--dc20 95-5962
 CIP

Published by Schiffer Publishing Ltd.
77 Lower Valley Road
Atglen, PA 19310
Please write for a free catalog.
This book may be purchased from the publisher.
Please include $2.95 postage.
Try your bookstore first.

Contents

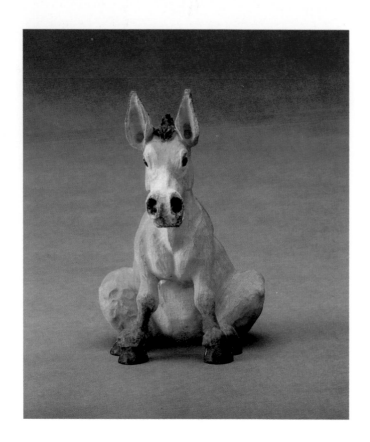

Most people see horses as noble steeds. Nothing is prettier than a well-bred horse...that's for sure. At the same time, though, the horse lends itself to caricature very nicely. A little extra sag in the saddle, bonier hips, longer ears, and the horse becomes comical. By exaggeration the horse can be made to express a variety of emotions and attitudes, from mulishness to exhaustion.

I once owned a pony. Seems I won a hog in a chicken fight one time. Now I didn't have any place to put the hog, so on the way home traded it for a Shetland pony. This was a nice pony, a registered stallion perfect for stud, and gentle to boot. Even though I had no more place for a pony than I did for a pig, I took it home. My kids were still young and I was sure this pony was just what they needed. I put up an electric fence, for the horse and went to bed, pretty pleased with myself.

Well, the man who traded that pony to me must have given it something to calm it down, because in the morning it was the wildest little stallion I'd ever seen. I decided right then to trade it, and walked it down the road to my Uncle Chicken. "Uncle Chicken," I said, "I'm going to sell you a pony."

"No you ain't," he said. "I don't want an old pony."

"But this pony's different. He's got breeding, and papers. People will pay to have him for stud."

"Well," he said, thinking it over. "If he's that good, he's worth more than I got."

"How much you got?"

He reached in his pocket, and pulled a twenty. "$20's all."

"That's enough." I took the money, handed him the reins, and hightailed it outa there. I heard that the second day he had the pony, the pony jumped over the fence and got a registered Tennessee Walker with colt. Speaking of "horses of a different color," that sure must have been one.

A few months later I saw Chicken. "How you doing with that pony I sold you?" I asked.

"Well, I had old Snowy (that's what I named him) out there in the lot. A guy came up with a pretty little filly and said he wanted Snowy for stud. 'Going to cost $50,' I said. 'Thought you'd trust me,' he said, 'I don't have the money right now.' 'Maybe you better come back when you do, I said. Just then old Snowy came over to the fence and started neighing, 'Trrrust him! Trrrrust him!'

Country folks have always depended on their horses for their livelihood. I can remember when I was young my dad bought a horse from my Uncle Pete. It was a plug horse, old and not very sturdy, but looked pretty good, and the price was right. Dad took him home and put in the barn.

Come morning Dad went out to the barn and found the horse stone dead. Not a little angry, he took off to tell my uncle what had happened. "Pete," he said, "you know that horse I bought off you..." Before he could say another word Uncle Pete said, "We're talking about your horse not my horse, aren't we?"

Maybe that's why my daddy always told me that there's more horse's asses than there are horses.

I hope you enjoy this book and the projects in it.

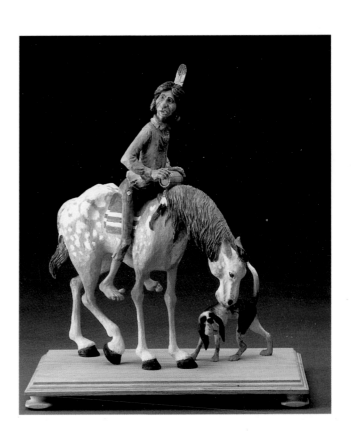

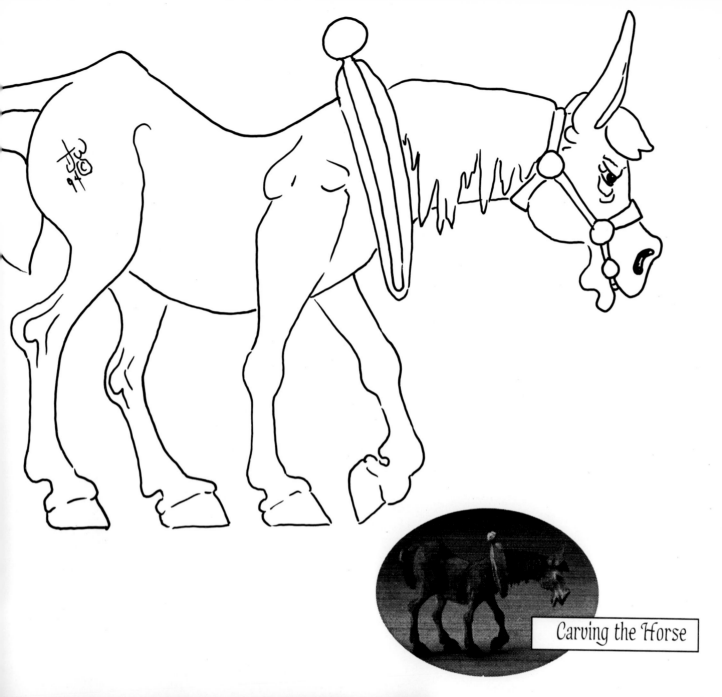

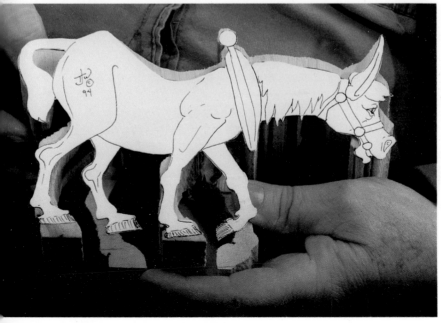

Carving the Horse

Cut the pattern from a piece of basswood. I use a piece four inches thick to cut the pattern on the band saw. Then I cut it down the middle to create two blanks. Cut between the legs, then drill or carve the extra legs away. You can do this in any pattern.

Clean the drill marks off with a gouge.

Mark the collar and the side views of the tail on both sides.

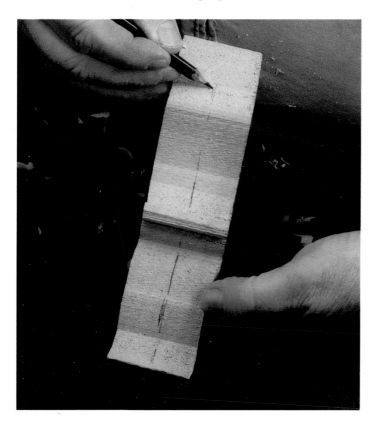

Draw a center line around the whole piece.

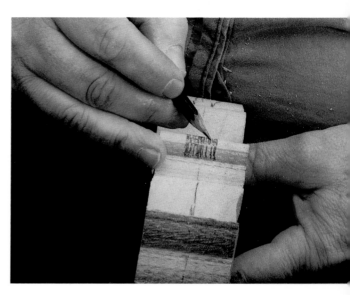

Mark the gap between the hames of the collar...

Decide which way the tail will flop, and mark it.

and the space between the ears.

Mark where the head will need to be narrowed.

Trim the neck to bring the collar out from it.

The sides of the head can be removed by carving or sawing.

At the back of the collar, start at the corners and cut a stop.

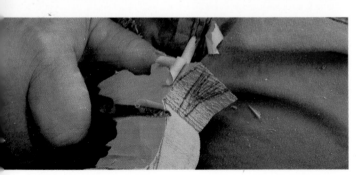

If you use a saw you will still need to clean up the sides with a knife.

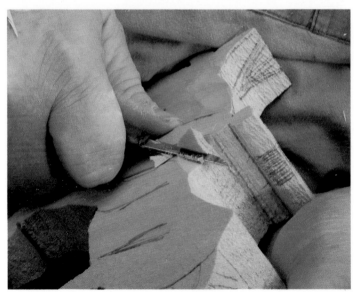

Trim back to it from the back.

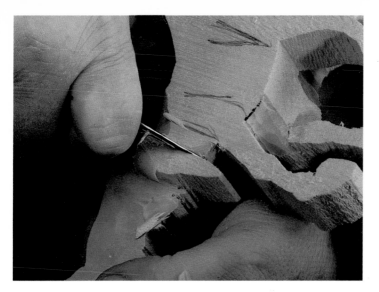

Do the same...

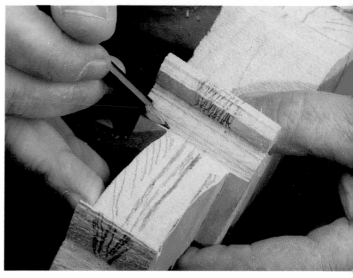

Draw the width of the mane at the top of the neck, and the direction the mane will fall.

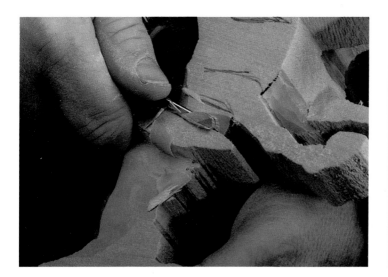

at all four corners of the collar.

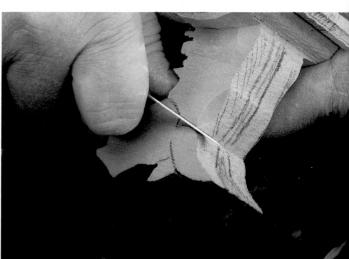

On the mane side of the neck cut a stop at the base of the ear...

Progress on the back side of the collar.

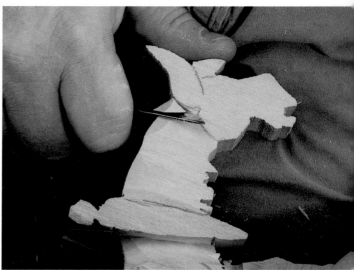

and trim the neck back to it.

Round the top of the neck on the mane side. The mane will roll over and fall straight down.

and come back to it under the neck with a gouge.

Under the neck draw the thickness of the mane and the area to be removed.

On the other side of the neck cut a stop in the jaw line...

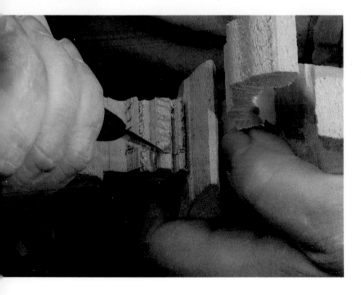

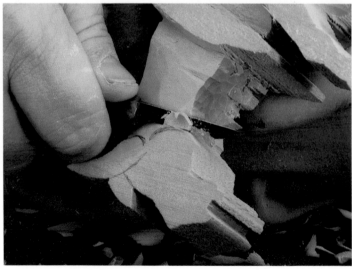

Cut a stop in the line of the mane...

and cut back to it.

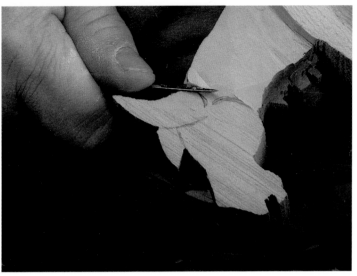

Do the same at line of the ear.

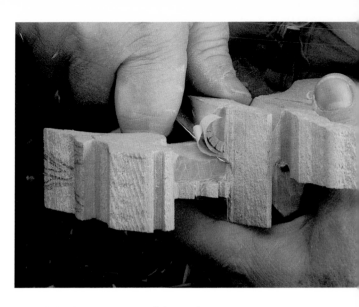

Round the bottom corner of the neck.

Knock off the other side of the neck.

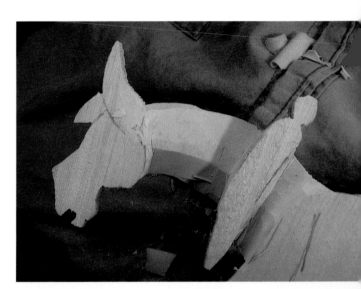

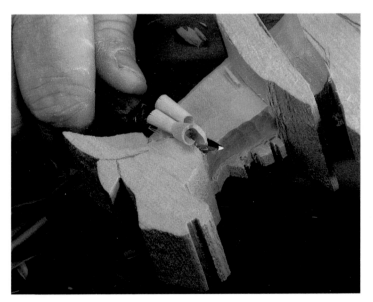

This side needs to go in a little further because it has no mane.

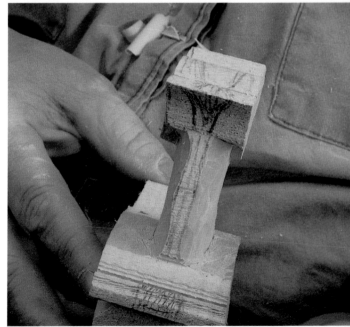

Progress.

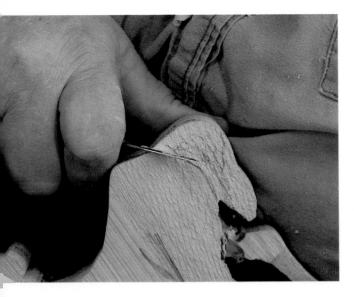

Cut a stop in the corner of the tail...

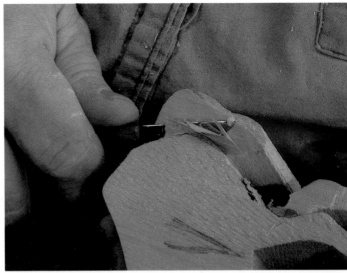

Cut back to it from the tail.

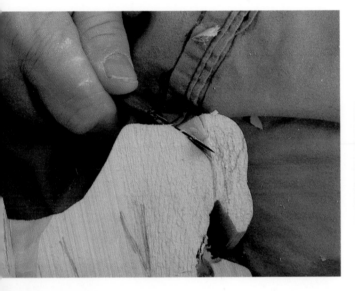

and come back to it.

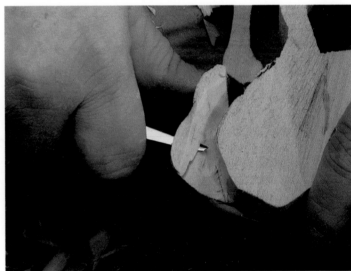

With that done, remove the sides of the tail.

Continue to work your way down the rump to the line of the tail. Take a heavy stop down the line of the rump.

Repeat on the other side, cutting a deep stop along the line of the rump...

and trimming back to it from the tail.

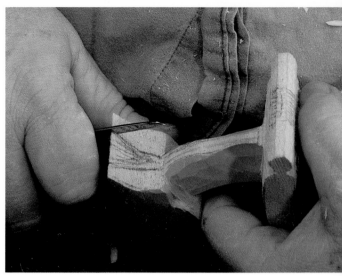

Remove the wood between the ears by making a stop on the line....

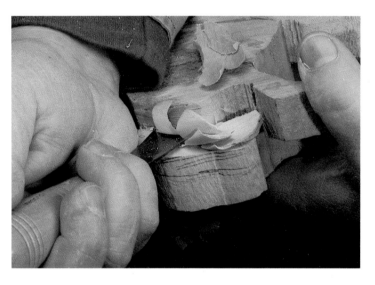

Continue the removal until you get to the width of the tail. A gouge may make this easier.

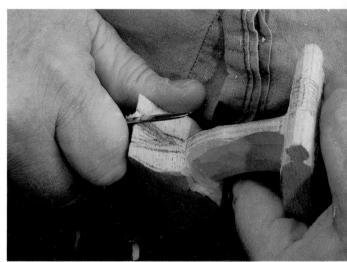

and slicing back to it from the middle.

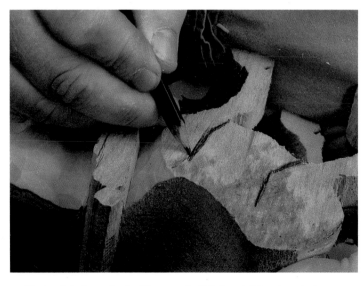

Draw details on body. You can do this by sight or by photo-copying the pattern and cutting it out.

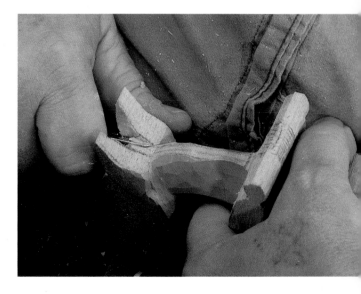

Continue down to the top of the head.

Keep every thing square for now.

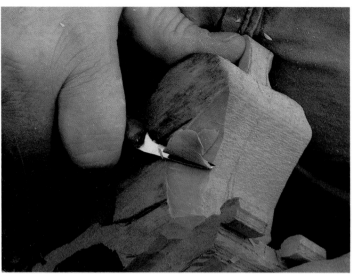

Knock the edges off the saddle area. This will make it easier to hold.

Use a similar process on the collar hames, cutting a stop in the line, and trimming back to it.

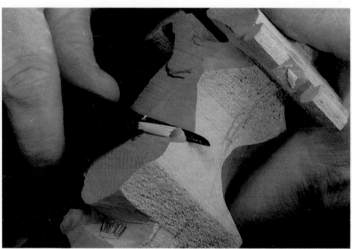

Repeat on the other side.

Keep these square for now too.

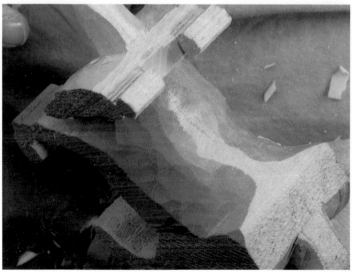

The result.

Knock off the edges of the hips.

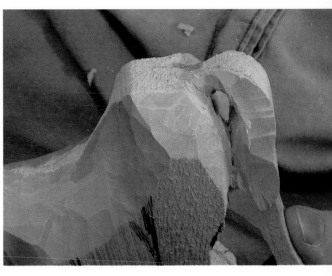

Progress on the tail.

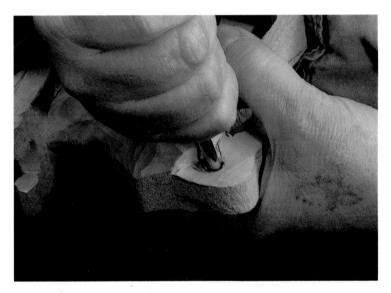

Drill the hole in the tail and clean it out with a gouge.

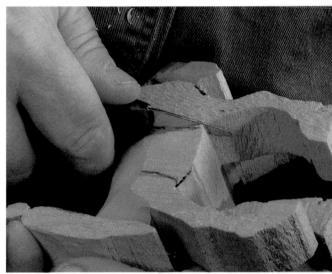

Begin rounding the belly by making a stop on the line of the back leg...

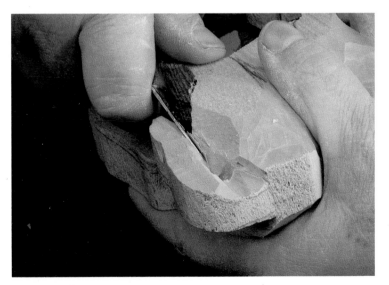

Continue working the line of the tail with the knife. You want it to look like it is separate from the body, while leaving it attached for strength.

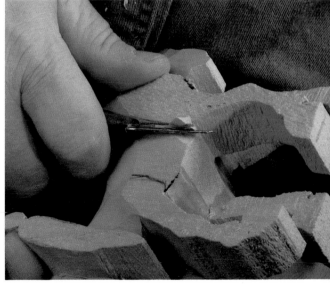

and cutting back to it.

Do the same at the front, cutting a stop...

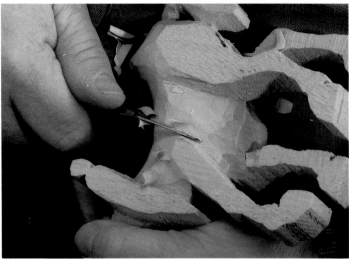

Continue to work your way down in the same way. Repeat on the other side.

and trimming back to it.

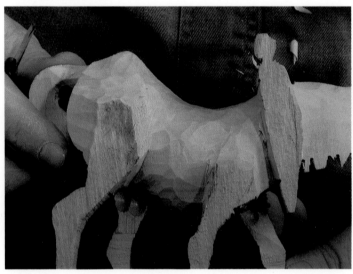

Take the belly to about this shape.

Knock off the edge of the belly between the two stops.

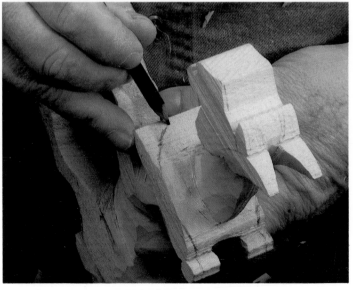

Draw in the shape of the collar.

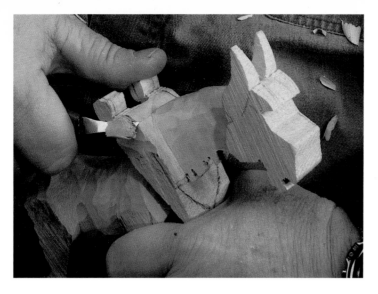

Knock off the excess at the top...

The bow marked, I use a gouge to begin at the crotch to remove the wood between the legs.

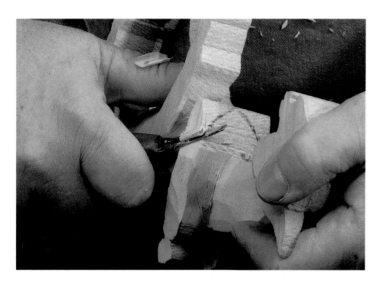

and the bottom. This gets the collar out of the way while we move to the legs.

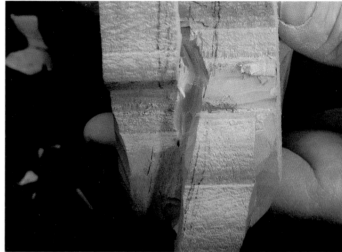

This gives me a place to start with my knife.

Mark the width of the feet. A mule walks narrow footed and is more comical if bowlegged, so we take off the outside. The raised front foot however looks like it should be further out, so I mark the inside for removal. You have to make some judgement calls along the way.

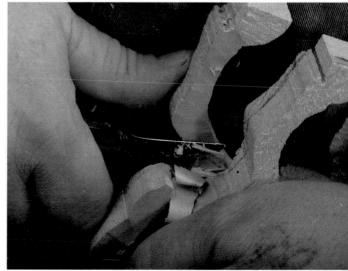

Trim between the legs.

With the back done you can see the bow that results.

You should end up with a nice bow between the legs, front and back.

Work from the top of the foot up, and trim the front legs.

Take a measure of the narrowest point of the legs.

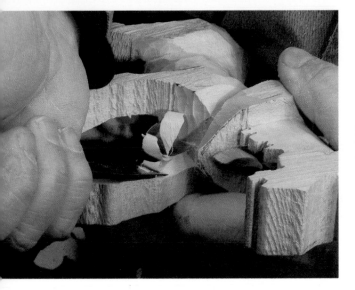

You may find it easier to use a flatter gouge for this.

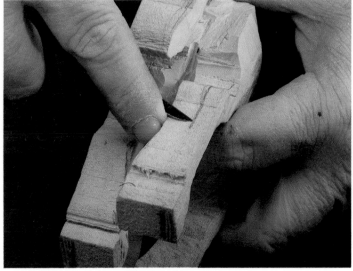

and transfer it to set the thickness of the all the legs, measuring from the inside out.

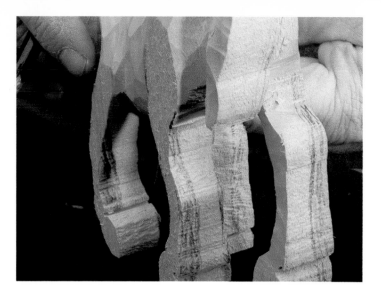

Mark the area to be removed on outside of each leg.

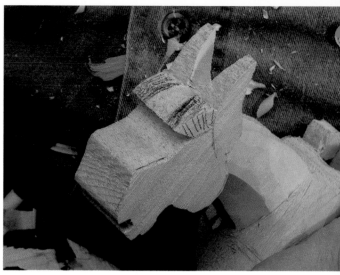

Mark the sides of the forelock to be removed.

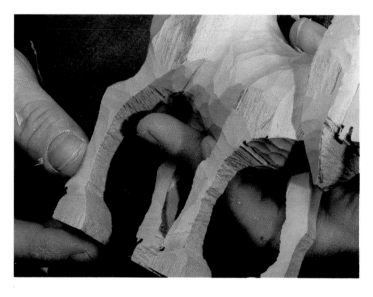

Trim the legs down to size.

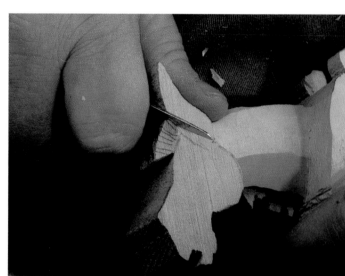

Remove the excess by making a stop in front of the ear...

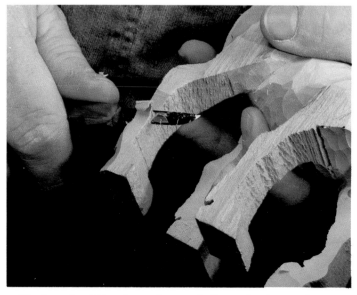

The legs should be nice and square before going to round.
This keeps proportions right.

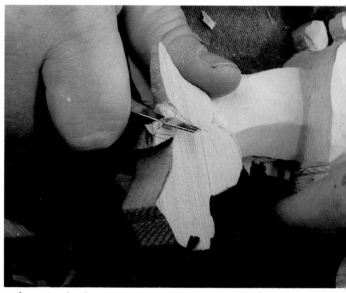

and coming back to it. Repeat on the other side.

To finish, cut a straight down beside the forelock...

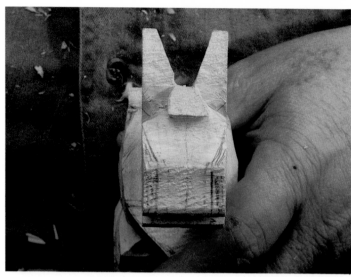

Mark the shape of the muzzle.

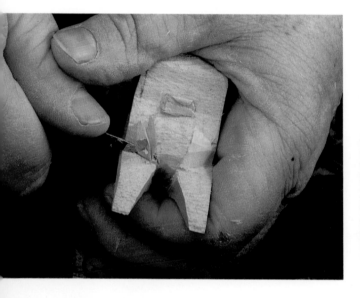

and nip off the shaving.

Use a knife to pop off the excess.

The forelock defined.

The result.

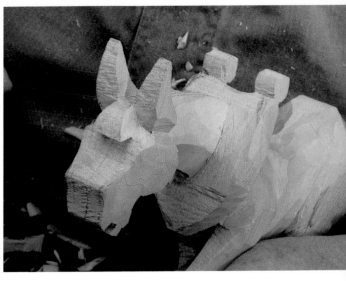

Mark the bottom corners of the ear to be removed. The most common mistake is not to bring the ears into the head where they need to be. Every animal on earth has the ear attached right at the end of the jawbone.

The result. This really helps make it look "muley".

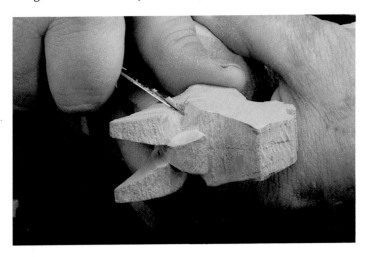

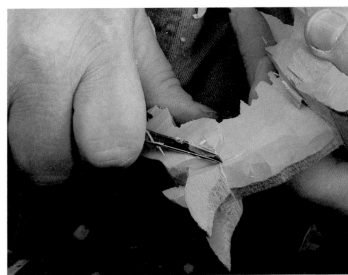

Slice at the bottom of the ear...

Leaving the eye socket intact, trim the jaw.

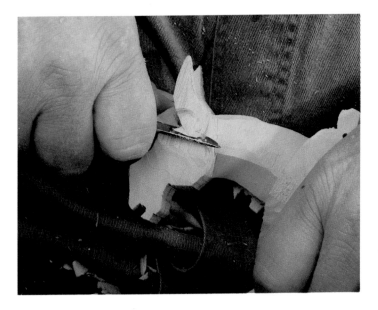

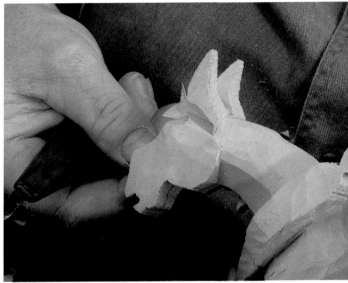

and cut back along the surface of the head.

On the non-mane side the jaw will be raised just a little above the surface of the neck.

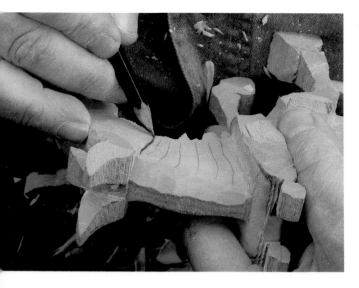

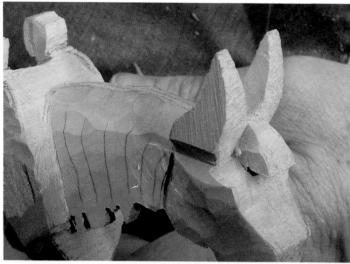

On the mane side, the first trim will take the jaw flush with the mane. Redraw the line of the mane along the jawline.

This leaves the mane hanging beyond the jaw.

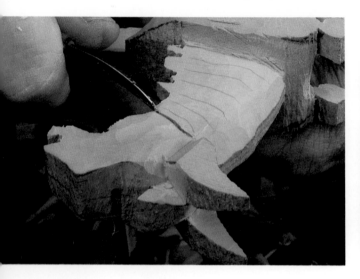

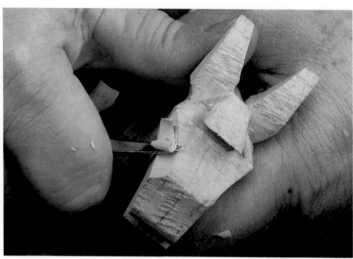

Cut a stop in that line.

Next we want to knock the corners off of everything, taking our square shapes to octagonal. Start on the head, leaving the eye socket pretty much untouched for now.

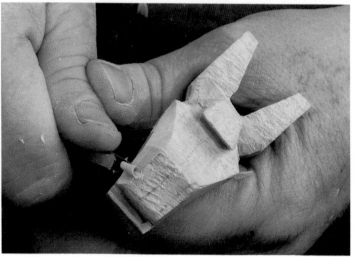

Trim back to it from the jaw, but not too deeply.

Continue down the nose.

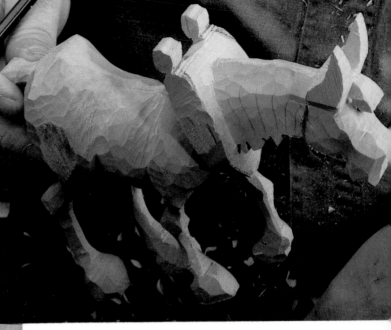

The lower head can be done in the same way, but don't trim the rounded part of the bottom jaw.

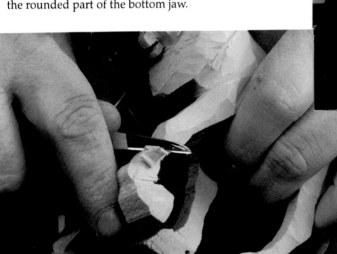

Ready for rounding.

Continue around the whole animal, taking off corners.

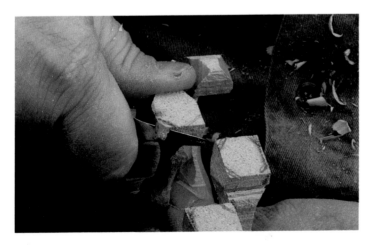

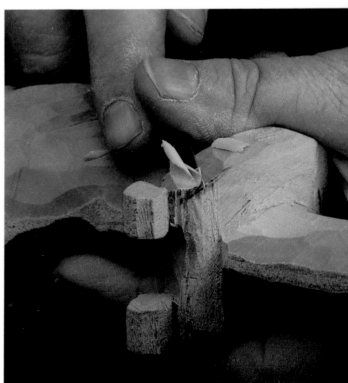

Trim the collar to bring out the hames.

The octagon goes even into the hoof. I did this for years before I realized what I was doing. I began to see the trouble my students had getting things round, and wondered why. When I paid attention to it I saw that I naturally went to octagonal before going to round and that this seemed to insure that the final product had nice proportions.

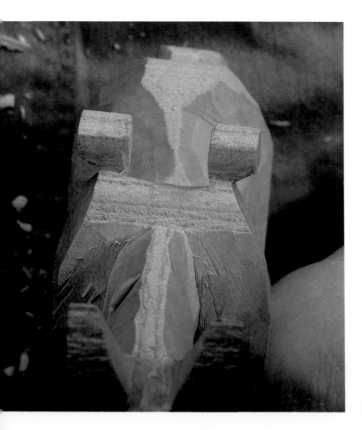

The result. The hames protrude beyond the width of the collar.

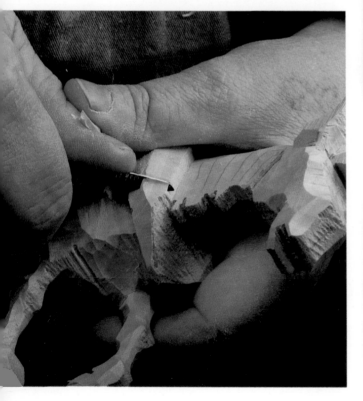

Knock off the corners of the collar.

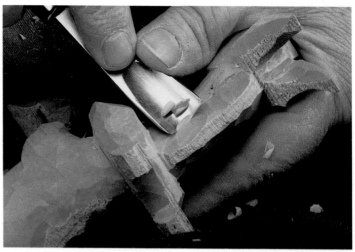

Cut a groove along the upper edge of the non-mane side of the neck. This brings out the muscle below that runs from the ear to the shoulder, and gives the mane a raised effect.

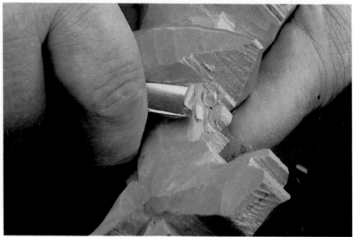

Make a similar groove along the bottom edge of the neck on the non-mane side.

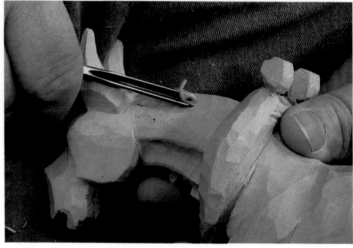

On the same side use a large veiner to mark the line of the mane were the hair stops.

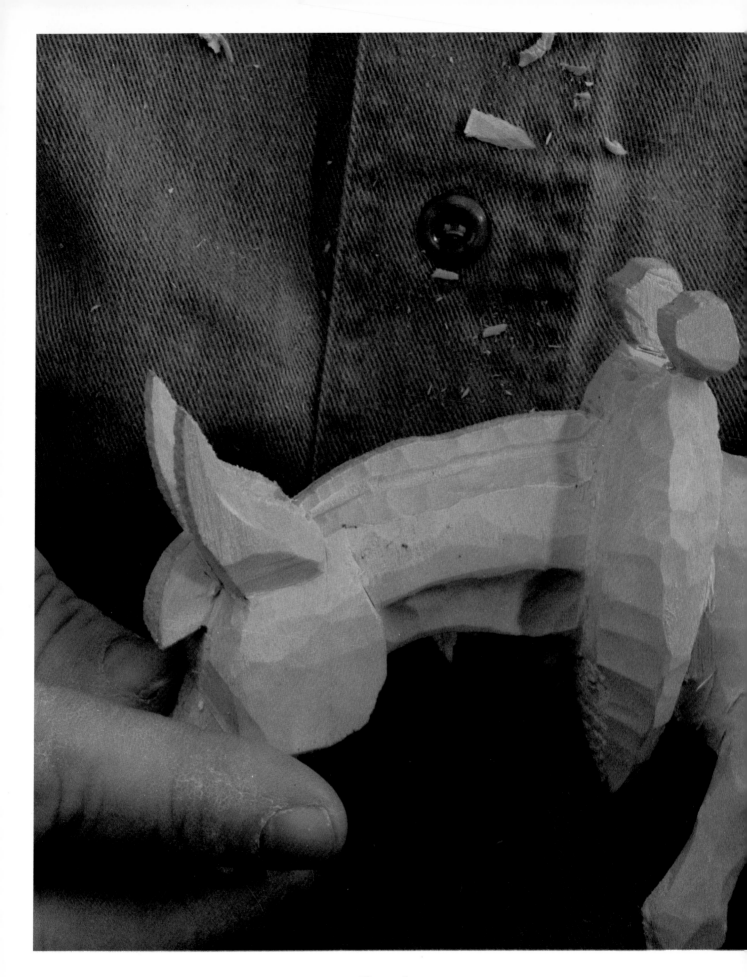

The result.

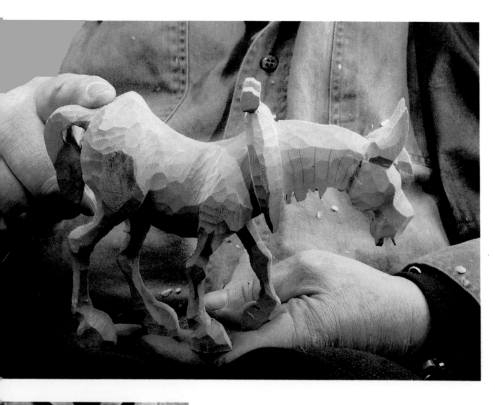

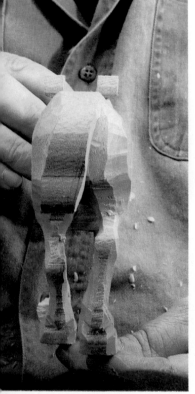

Ready for rounding.

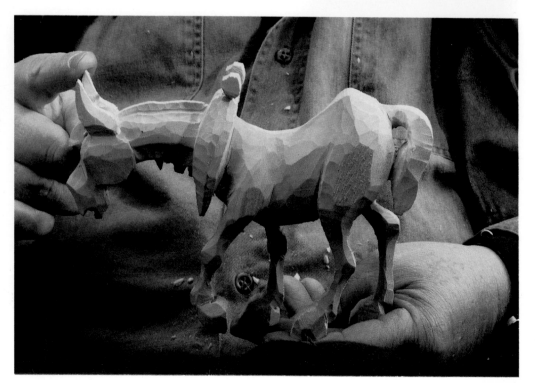

Oops! Forgot to take the tail to octagonal so I'll do it now.

Come over the top of the hoof with a gouge.

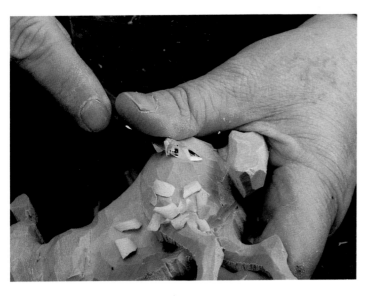

Go over the whole piece rounding it off.

Cup out the frog at the back of the hoof.

Shape the hoof at a good angle.

Mark the feet where the hard hoof ends and the skin and hair begin.

Go over the line with a veiner. You may need to change direction to go with the grain. This is important here because the foot is fragile and might break.

The result.

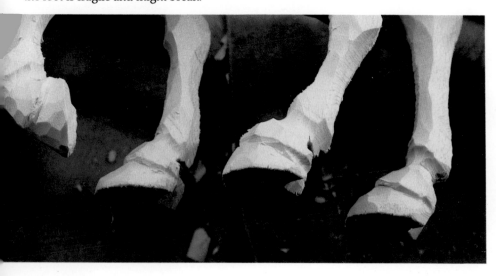

The hooves complete.

Carve a groove between the hips to bring out their boniness.

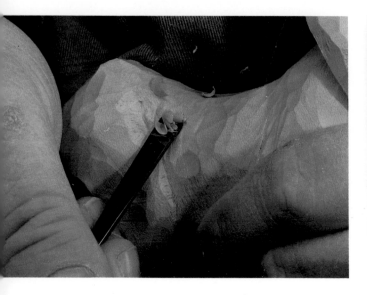
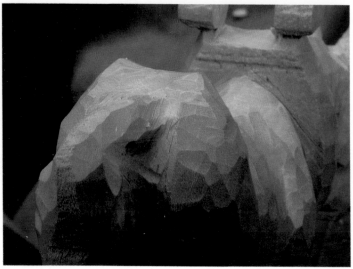

Use a gouge to create a gut cavity in front of the hip.

The result.

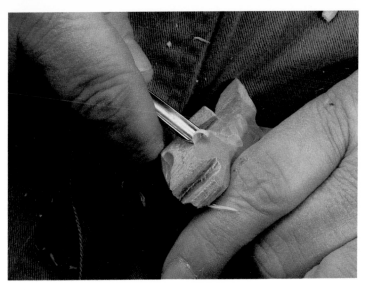

Moving to the face, gouge out the nostril holes.

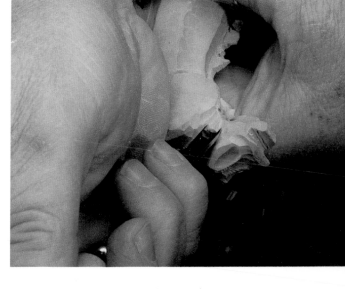

Narrow the muzzle behind the mouth.

Go around the back of the nostrils with the gouge, making them seem to flare out.

Make a groove under the eye.

Come down between the nostrils and under them.

Blend the cheek back into the groove.

The front edge of the ears curve back a little at the bottom.

Trim and round the area of the eyes, making them the same size. It's real important that they be alike.

Use a flatter gouge to clean things up.

Draw in the mouth. I'd like to show some teeth back in the mouth.

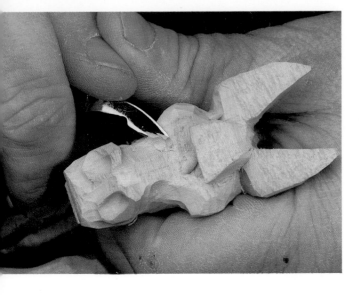

A knife also can be used to clean things up.

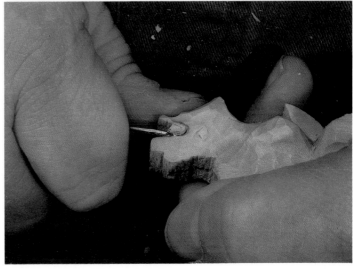

Cut a stop around the mouth line.

29

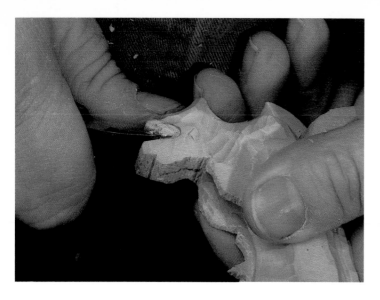

Clean out the opening.

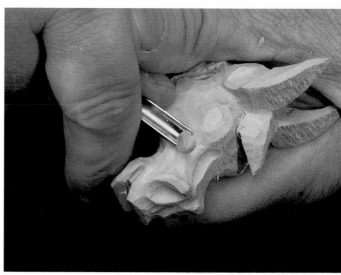

Run a groove from the nostril to the eye.

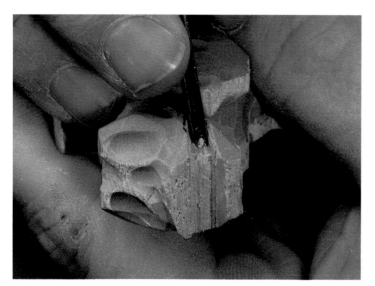

A veiner gets in here well. I don't go too deep, leaving wood for the teeth.

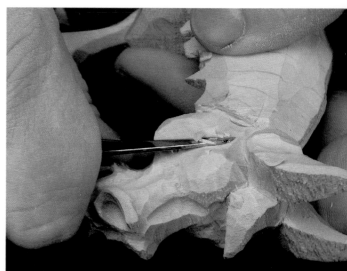

Smooth things up with a knife.

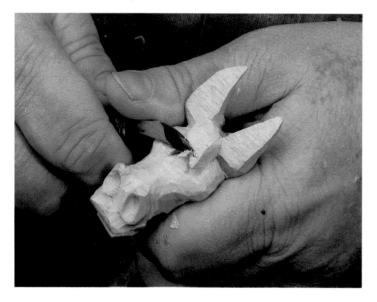

Give the forelock a little class by carving it off to one side.

Trim under the chin.

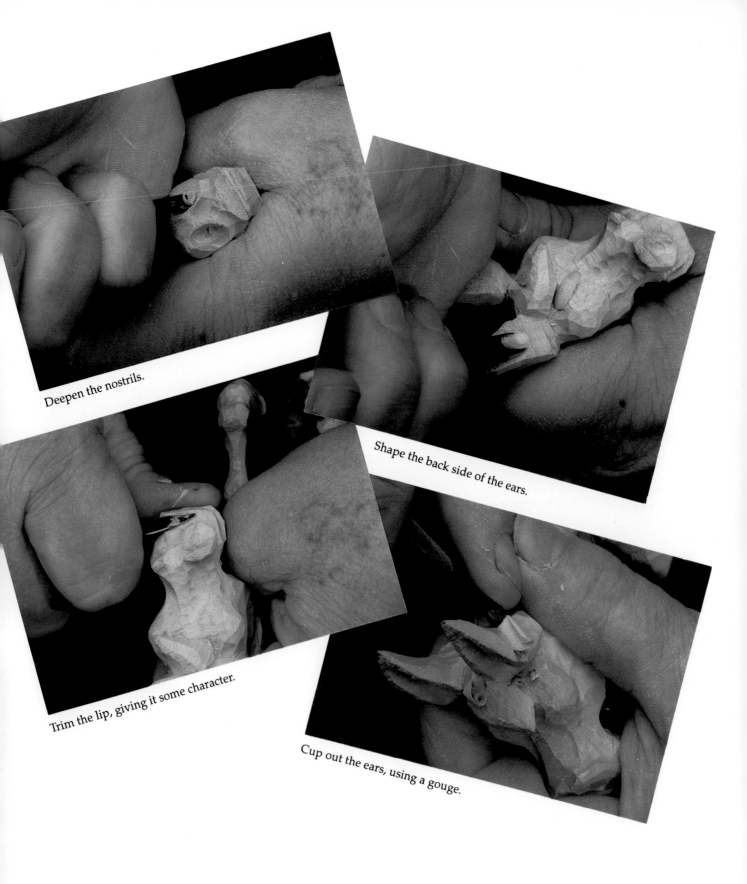

Deepen the nostrils.

Shape the back side of the ears.

Trim the lip, giving it some character.

Cup out the ears, using a gouge.

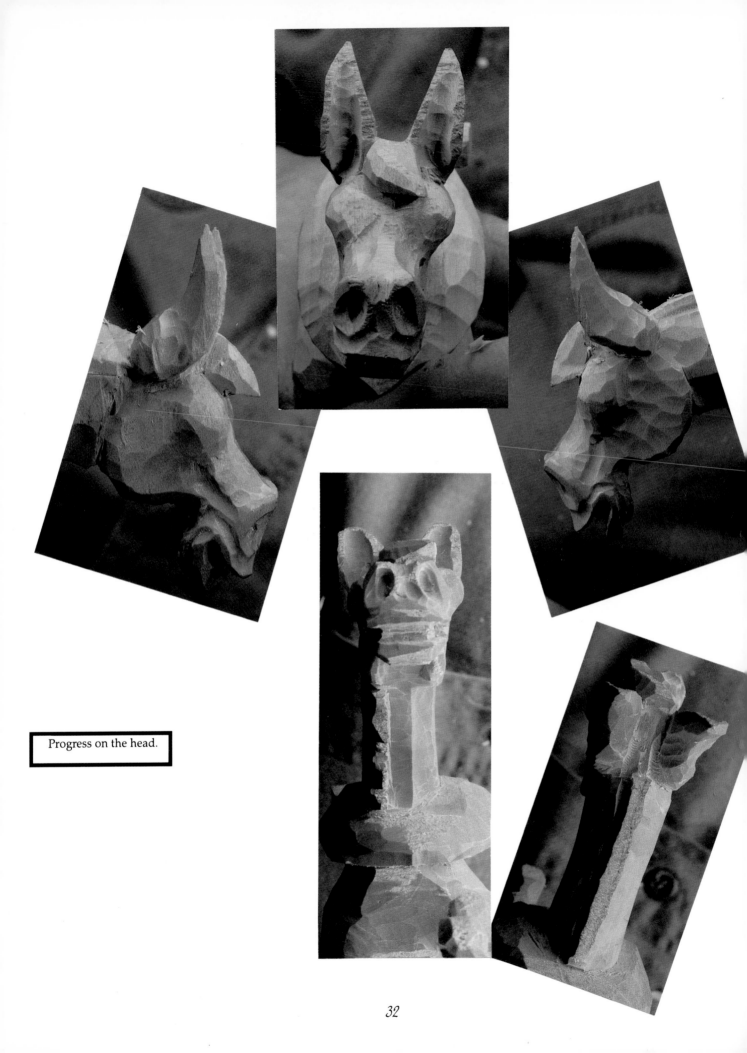

Progress on the head.

Begin rounding the hames by knocking off the corners.

Run along the line with a big veiner. This provides relief so I can come back with a knife without busting things off.

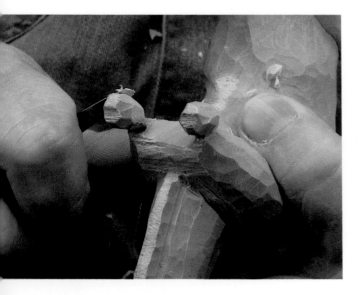

Keep refining them, working toward round.

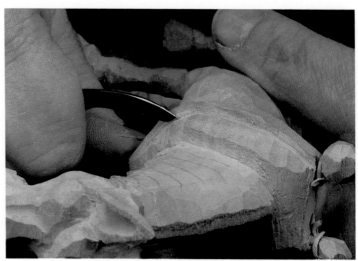

Cut a deep stop along the wooden part of the collar. You want the leather part of the collar to appear to go under the wooden part.

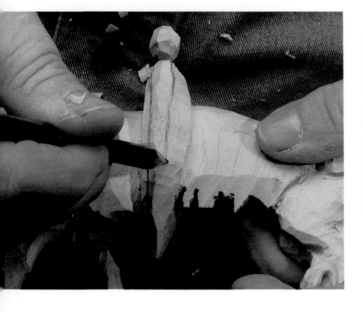

Draw in the wooden part of the collar.

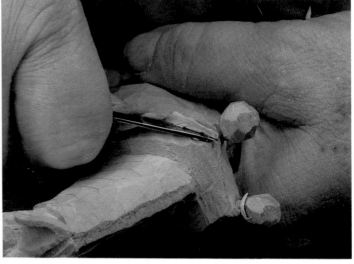

Cut back to the stop from the leather part of the collar.

Carve the back edge...

and down the back and front.

in the same way.

The result.

Leaders add life to the legs. Go from the back of the main joint up the leg...

Do the same on the inside of each back leg.

Use a small veiner to add some feathering to the hocks. A mule doesn't have much, but it seems to need a little.

On the front leg put a little accent right where the elbow sticks out.

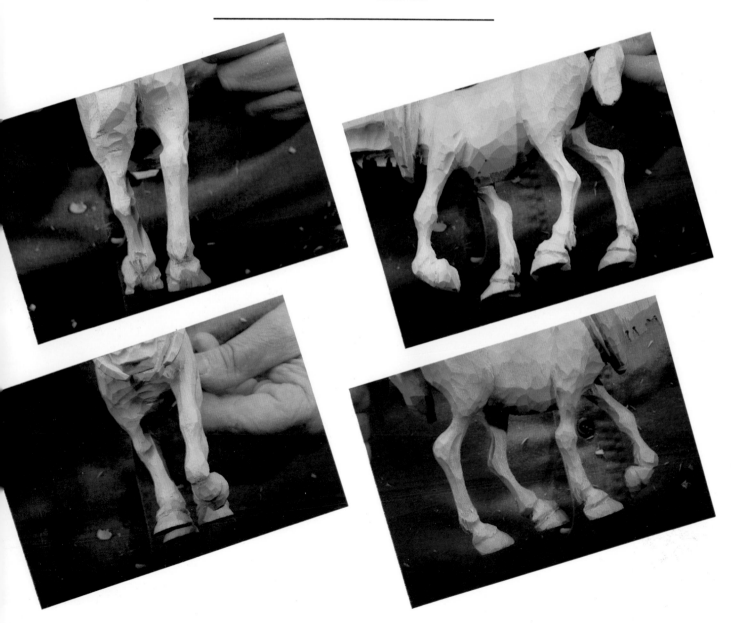

Progress on the legs.

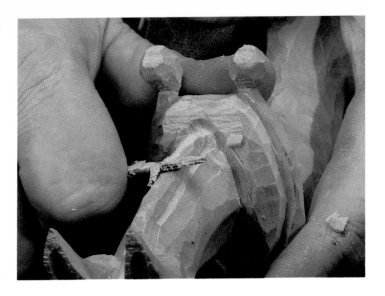

Remove the saw marks from the top edge of the mane...

Come from the other side of the neck and add snitches to the short side of the mane.

then carve the hairlines with a veiner.

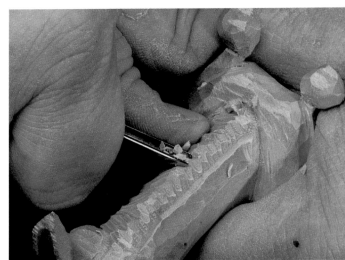

Go over the top.

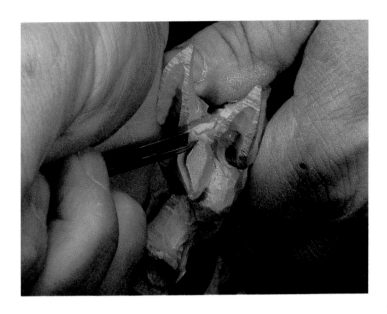

Continue the hairlines on the forelock.

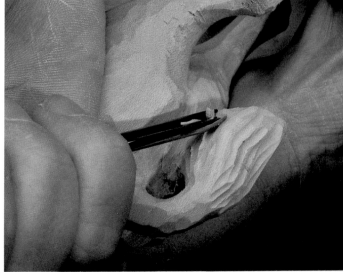

The mules are kind of broom-tailed. Put lines of hair in the end.

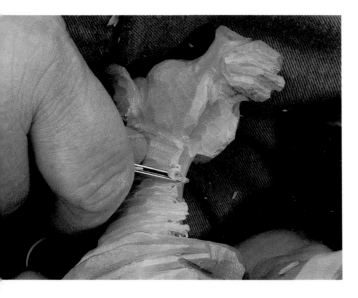

Dress up the end of the mane, making it look kind of ragged.

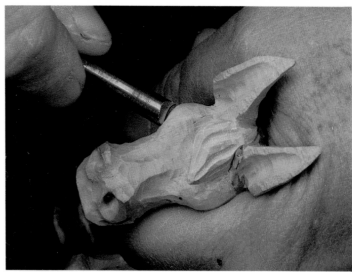

Place the punch and rock it forward...

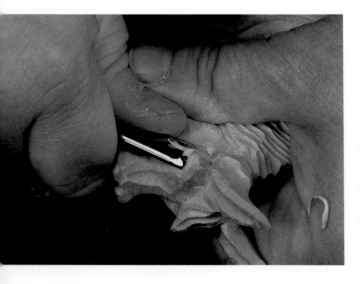

Use a gouge with the cup against the wood to smooth out the area of the eyes. This will also help get them to equal sizes.

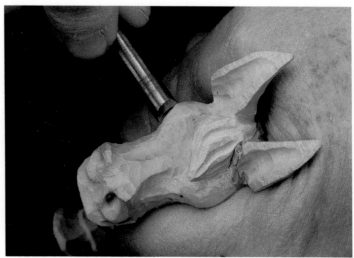

back...

Use an oval shaped eye punch to form the eyes. This is simply round eyepunch with the edges ground off both sides.

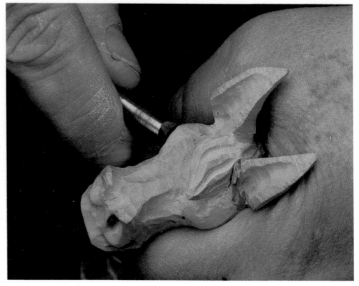

down...

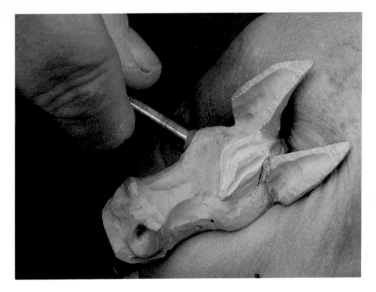

and up. I've exaggerated the movement so you can see it.

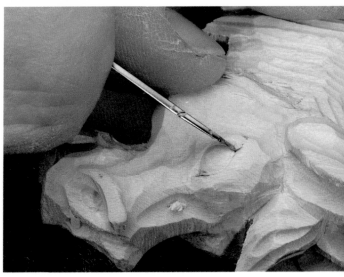

and, with the knife edge against the eyeball, push the blade into the corner to pop out the nitch.

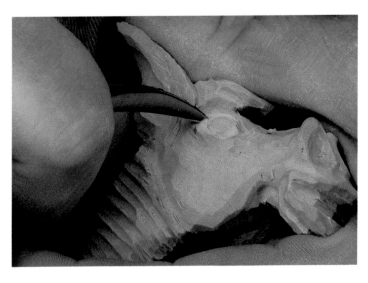

With a knife cut a line along the top edge of the eye...

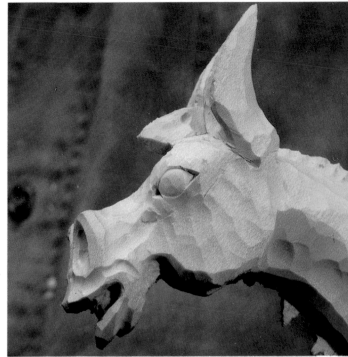

The result.

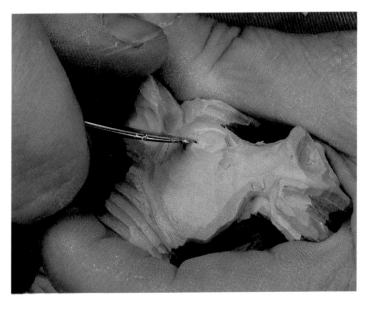

the bottom edge...

Create the eyelid by running the veiner under the eye...

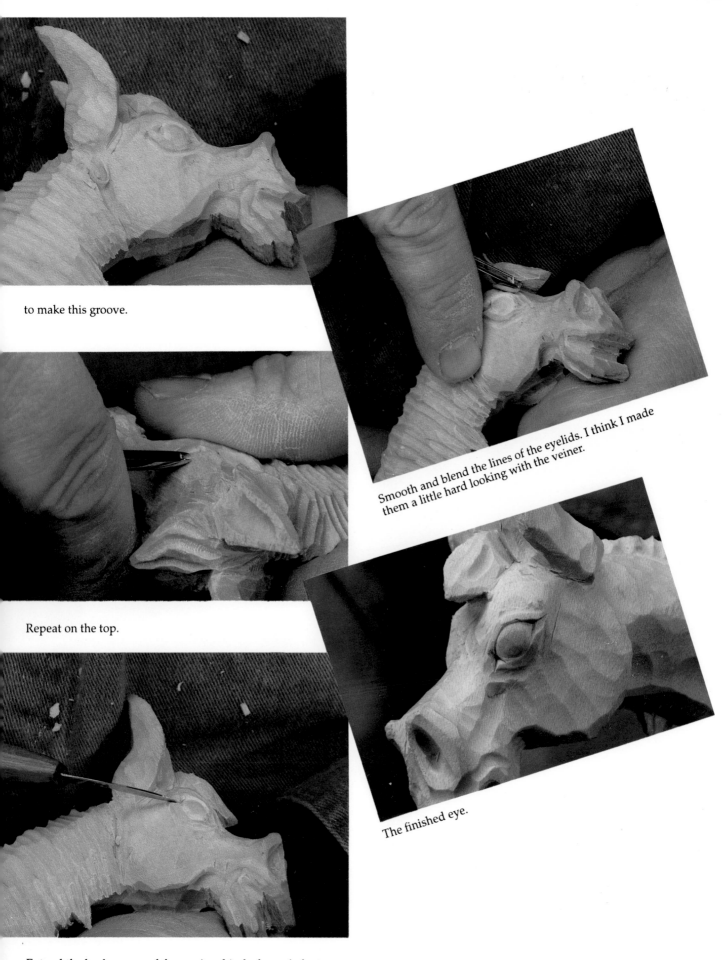

to make this groove.

Repeat on the top.

Smooth and blend the lines of the eyelids. I think I made them a little hard looking with the veiner.

The finished eye.

Extend the back corner of the eye in a kind of crow's foot.

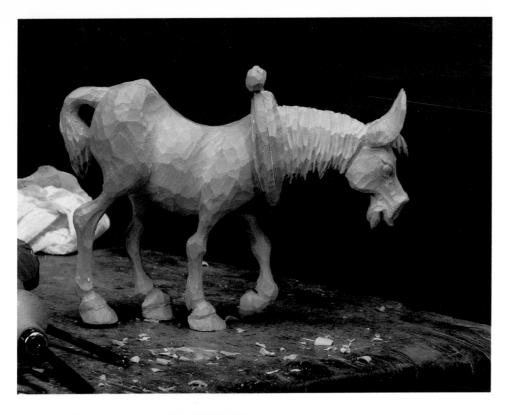

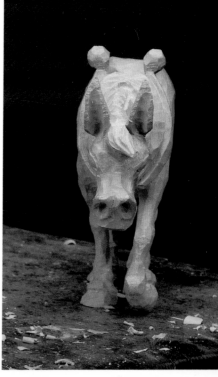

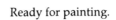
Ready for painting.

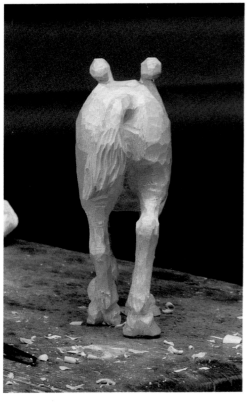

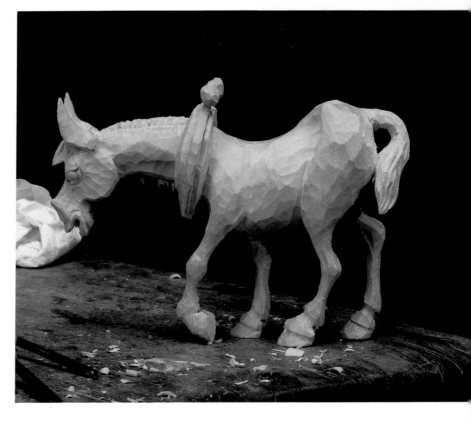

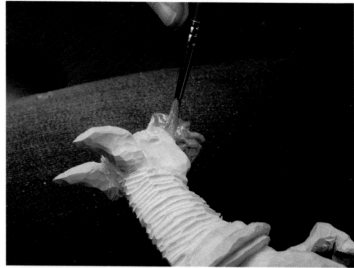

Begin with a wash of raw sienna, applying it to the lighter parts: the nose...

Painting the Horse

For wood carving I use Winsor and Newton Alkyd tube paints. Most coats are thinned with pure turpentine to a consistency that is soaked into the carving, giving subtle colors. What I look for is a watery mixture, almost like a wash. In this way the turpentine will carry the pigment into the wood, giving the stained look I like. It has always been my theory that if you are going to cover the wood, why use wood in the first place. It should be noted that with white, the concentration of the pigment should be a little stronger. With the dragon I use some pigments right from the tube to add some dry brushed color. This will become obvious as we proceed.

I mix my paints in juice bottles, putting in a bit of paint and adding turpentine. I don't use exact measurements. Instead I use trial and error, adding a bit of paint or a bit of turpentine until I get the thickness I want.

The juice bottles are handy for holding your paints. They are reclosable, easy to shake, and have the added advantage of leaving a concentrated amount of color on the inside of the lid and the sides of the bottle which can be used when more intense color is needed.

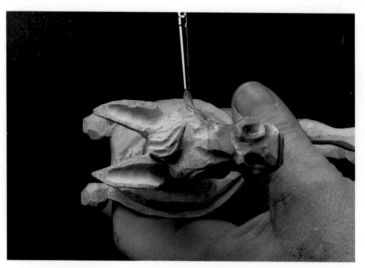

the eyes...

the inside of the ears...

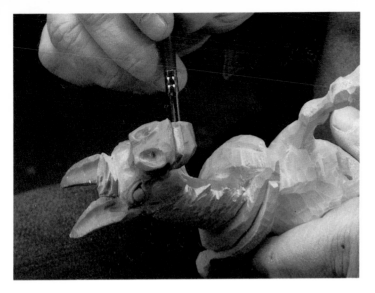

under the neck...

Apply a wash of burnt sienna to the ears and head.

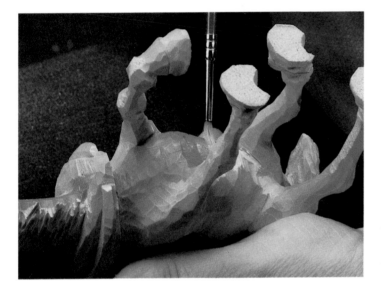

the belly...

It will fade into raw sienna where it meets it.

and a little bit on the inside of the legs.

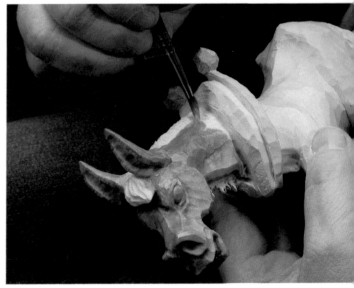

Continue with the neck...

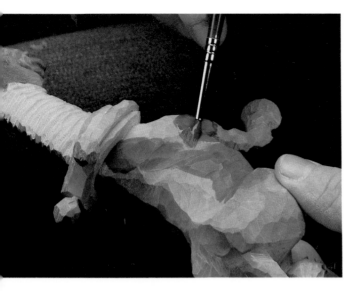

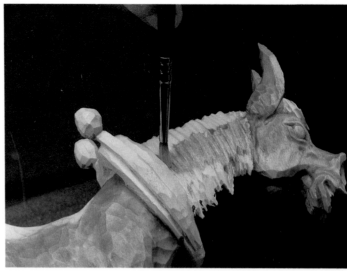

and the body. There will be an intense black over the back, so I won't put burnt sienna there.

and across the middle of the mane. This will make a nice highlight.

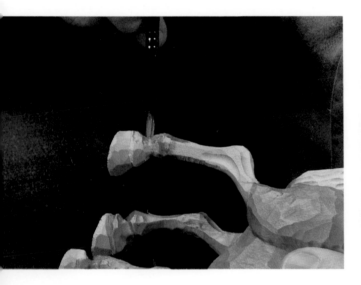

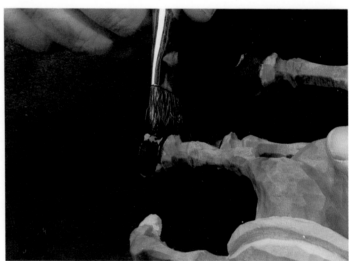

Paint the legs down to the hoof, but not on it.

A wider brush carries more paint and turpentine onto the hoof, giving them a good soak. Paint the hooves black.

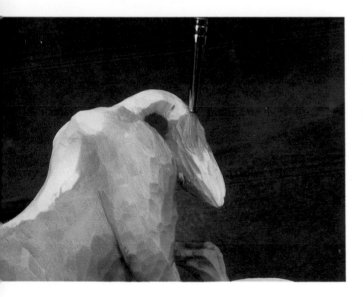

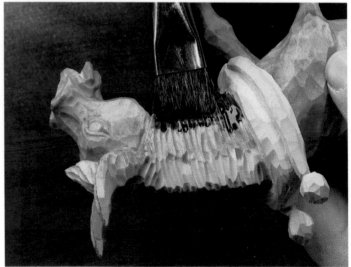

Carry a stripe of burnt sienna around the middle of the tail...

Apply black to the lower edge of the mane.

Switch to a smaller brush to do the top edge of the mane.

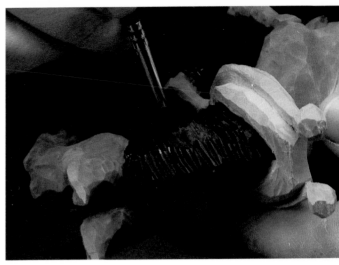

Go over the sienna stripe, brushing the black out so the sienna shows through.

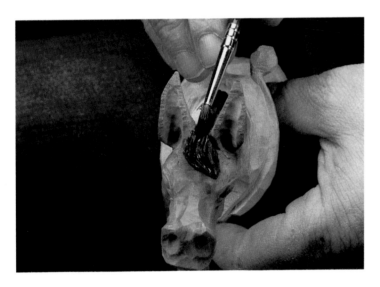

and the forelock.

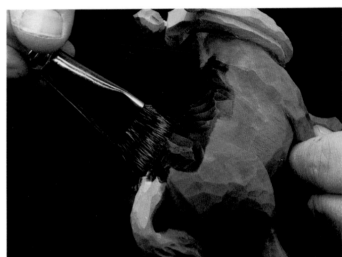

Paint the back, again blending into the side.

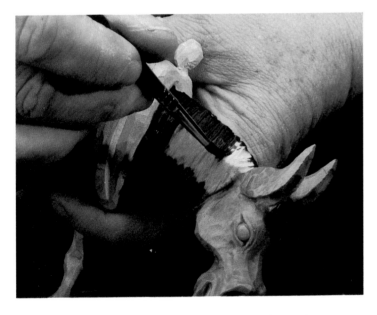

Blend the black of the top of the mane into the burnt sienna.

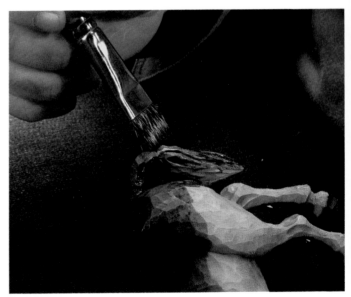

Continue with the tail.

Work the black down from the back, blending it into the body.

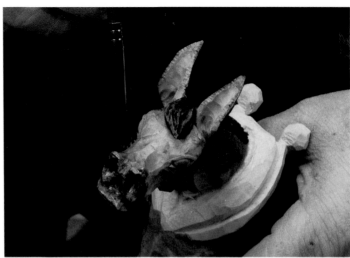

Blend it with a drier brush.

Add a heavier black to the end of the tail.

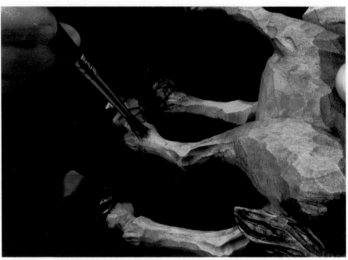

Carry some black up the lower legs.

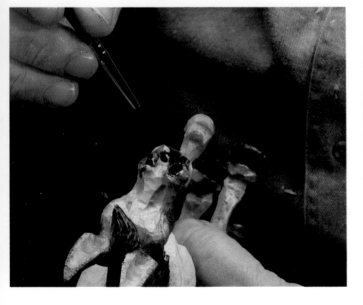

Add some black to the nose.

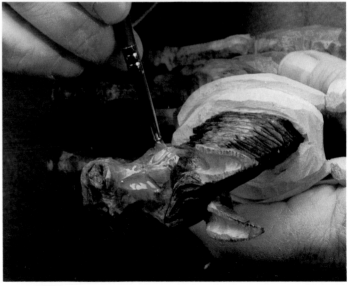

I'm using a little raw sienna to lighten up the face.

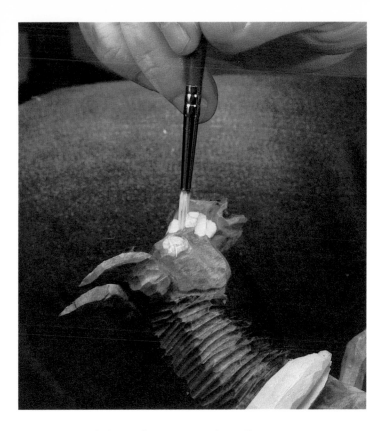

It's still too dark, so after wiping it down I'm trying some white.

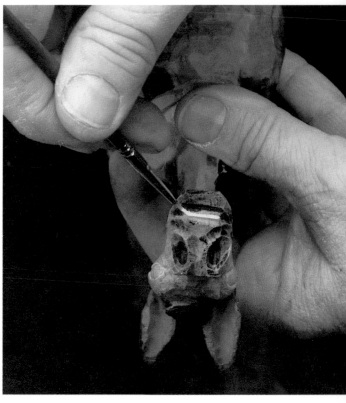

Add some heavier white to the teeth.

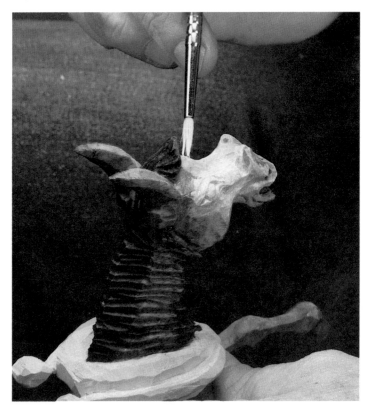

A heavier application of white around the eye gives the white ring that is common to jackasses.

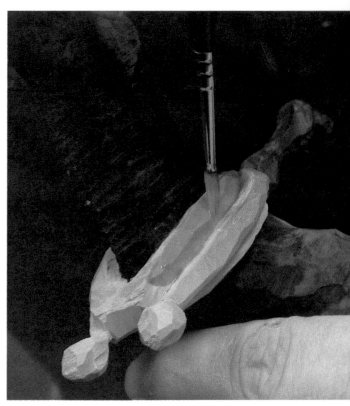

While we allow the eyes to dry a little, we'll do the collar. Apply raw sienna to the leather portion. front...

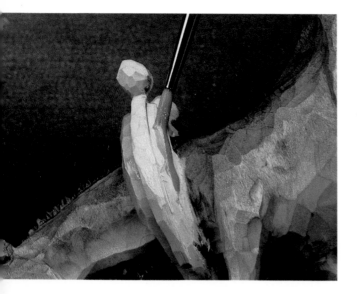

and back.

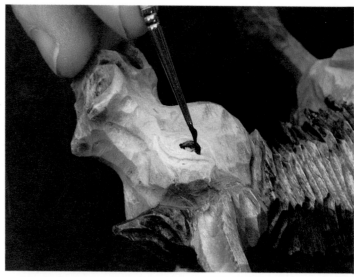

Apply black to the eyes.

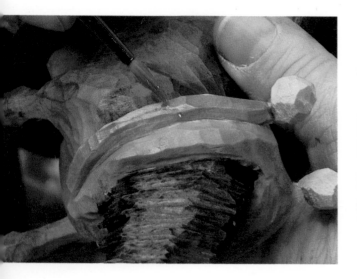

Apply burnt sienna to the wooden part of the collar.

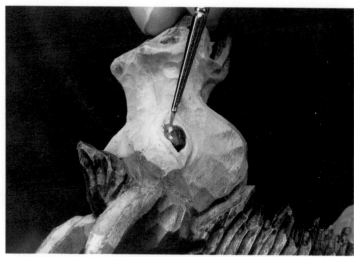

Add a speck of white high and to the back of each eye. This gives them life.

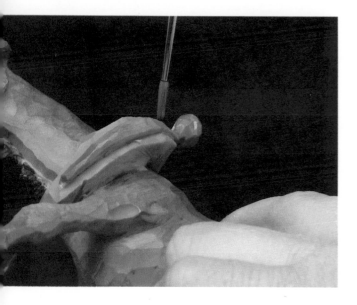

Paint the hames.

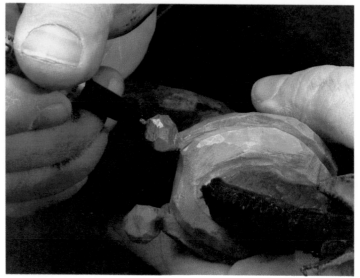

A metallic gold pen will make the knobs of the hames more realistic.

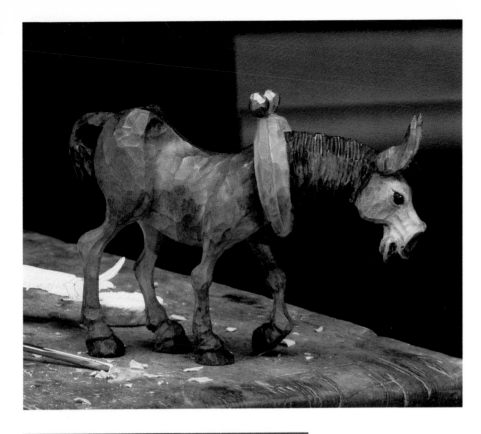

Finished

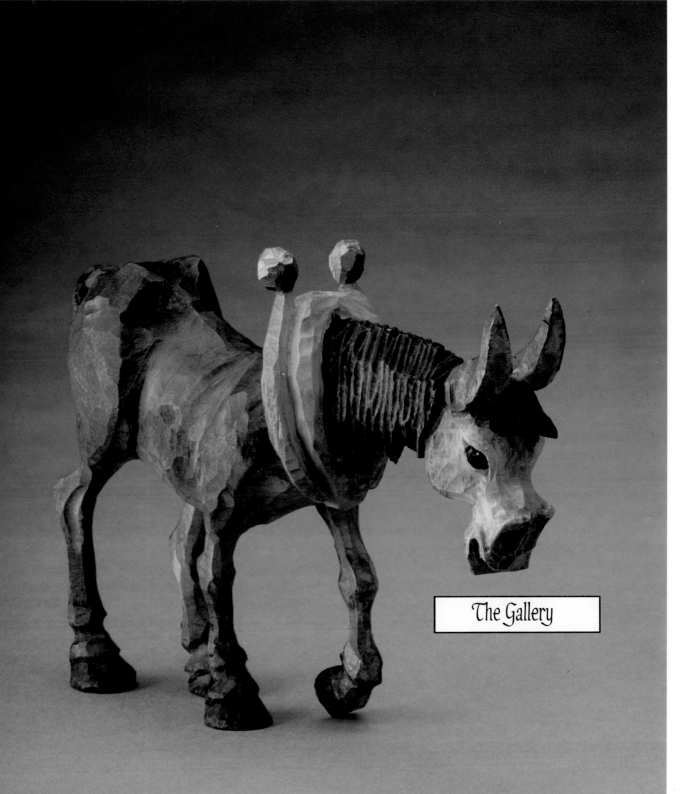

The Gallery

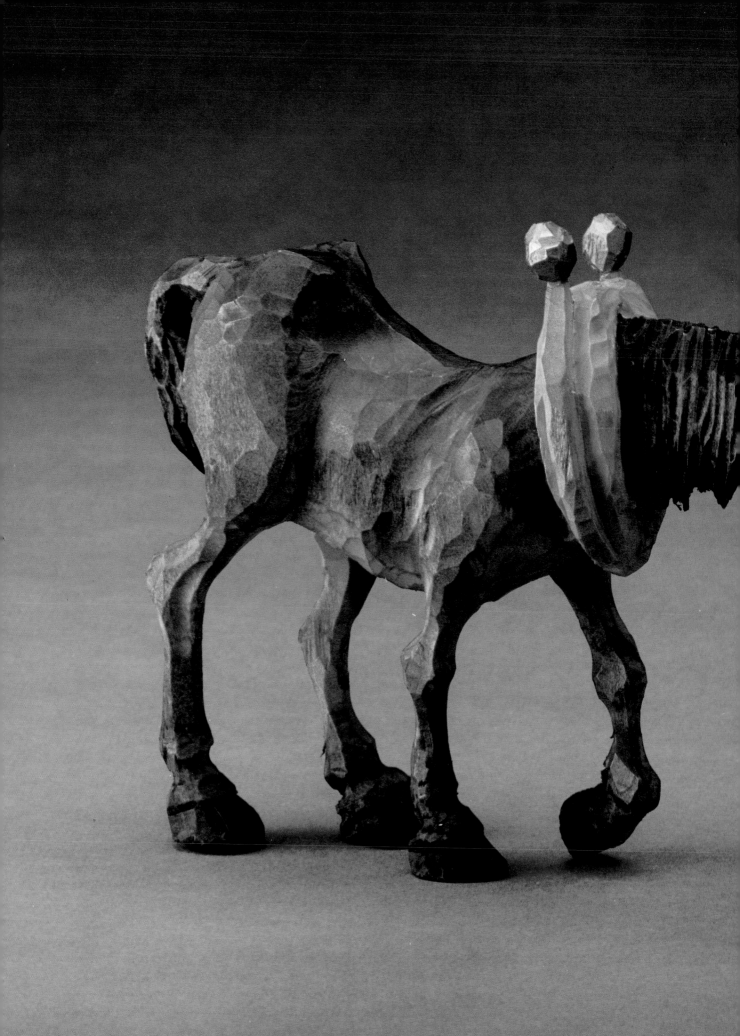

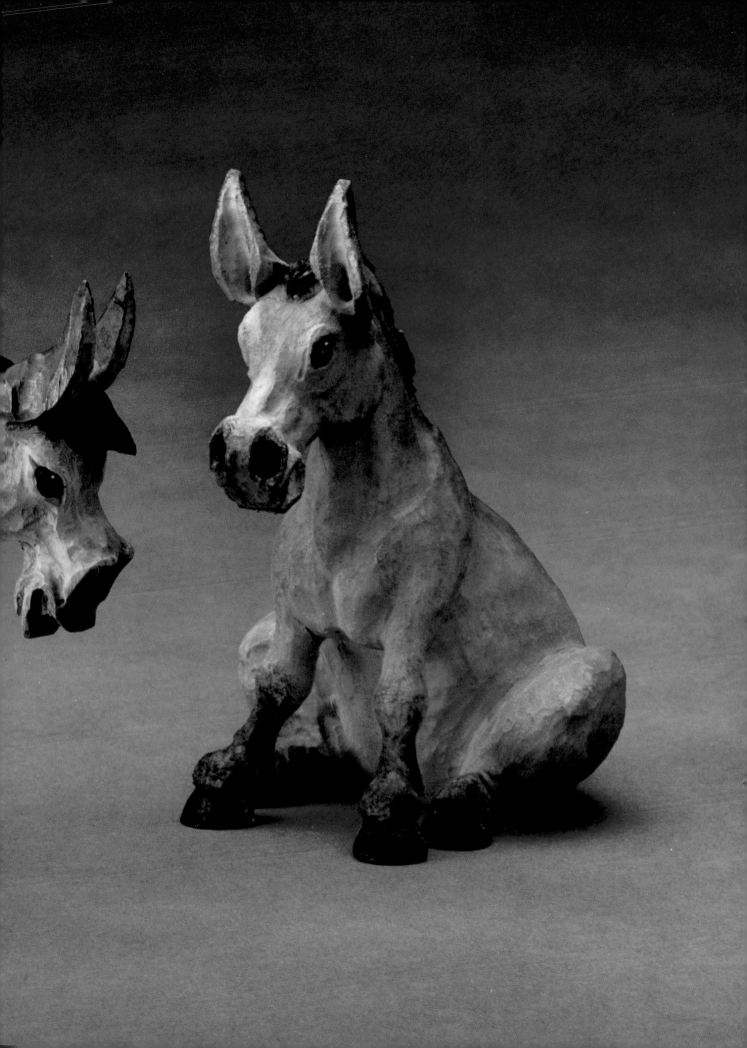

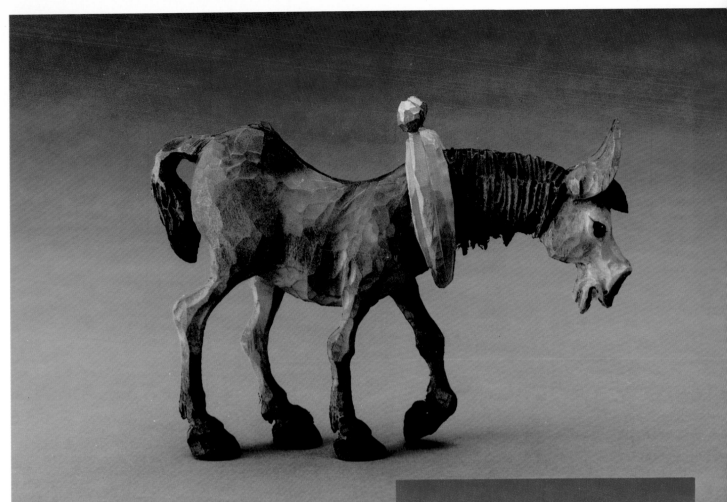

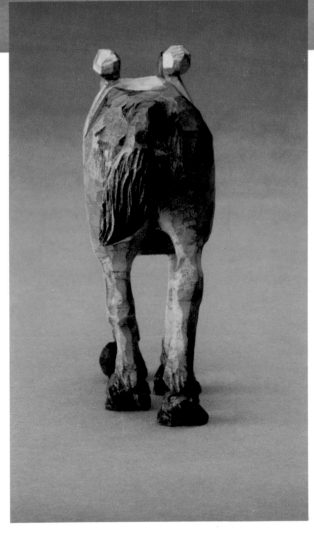

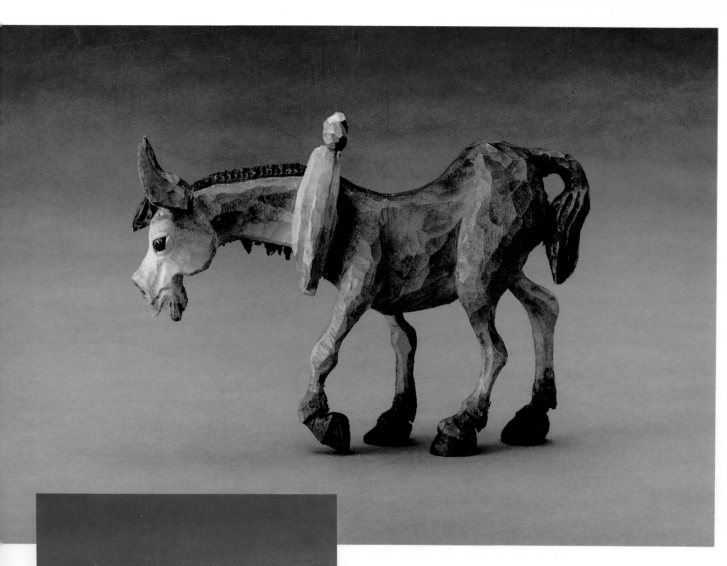

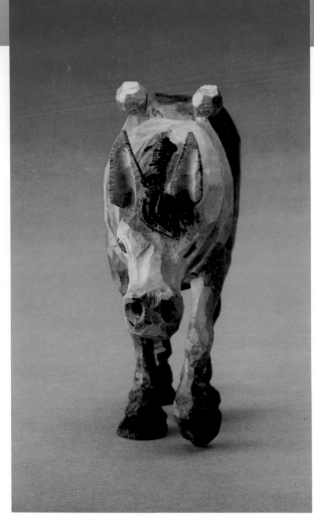

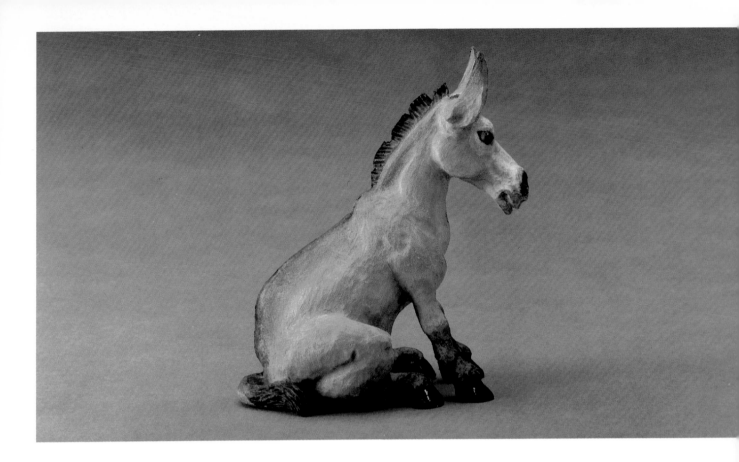

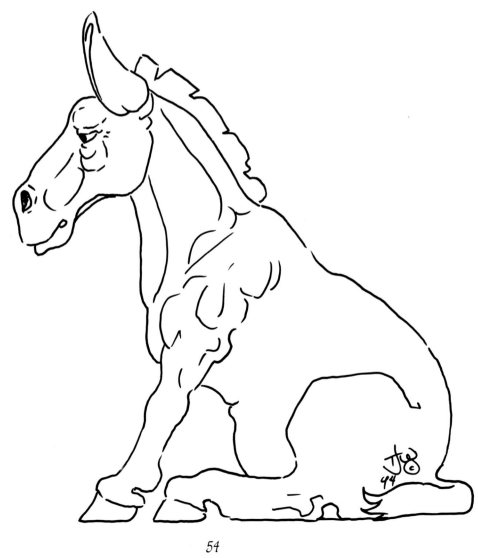

54

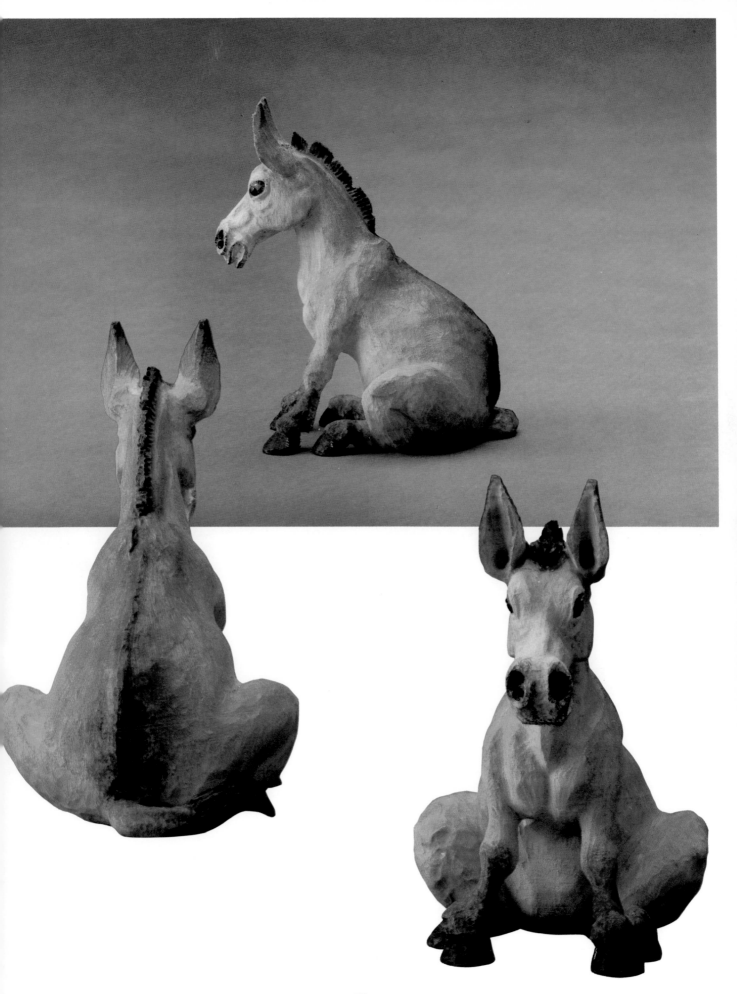

56

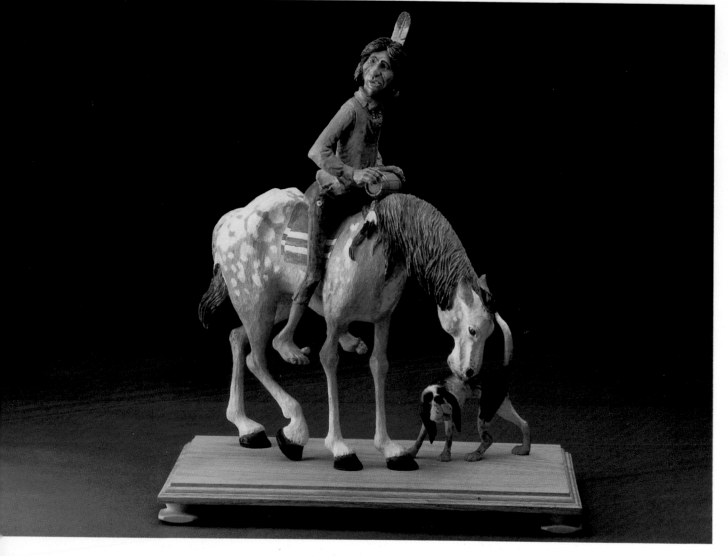

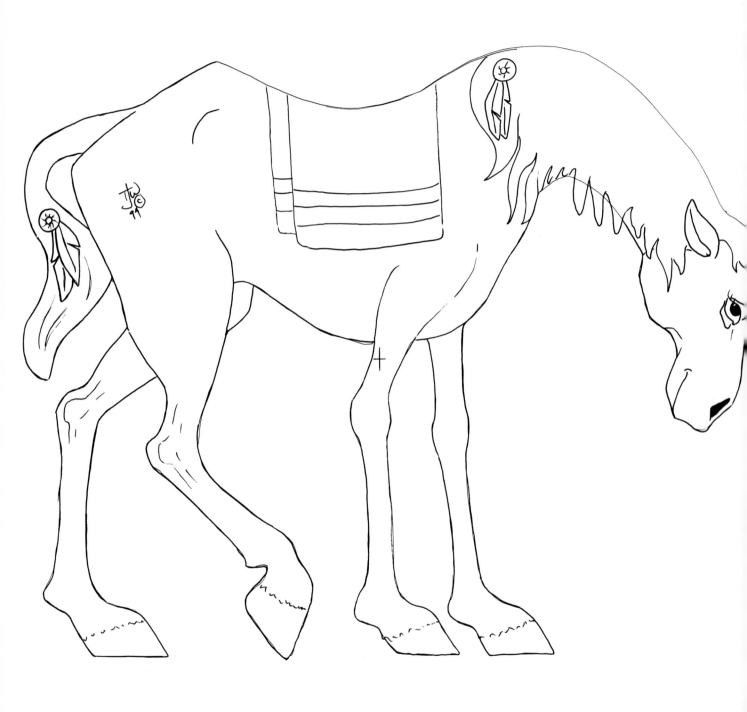

Pattern reduced to 70% of its original size.
Enlarge 143% to attain original size.

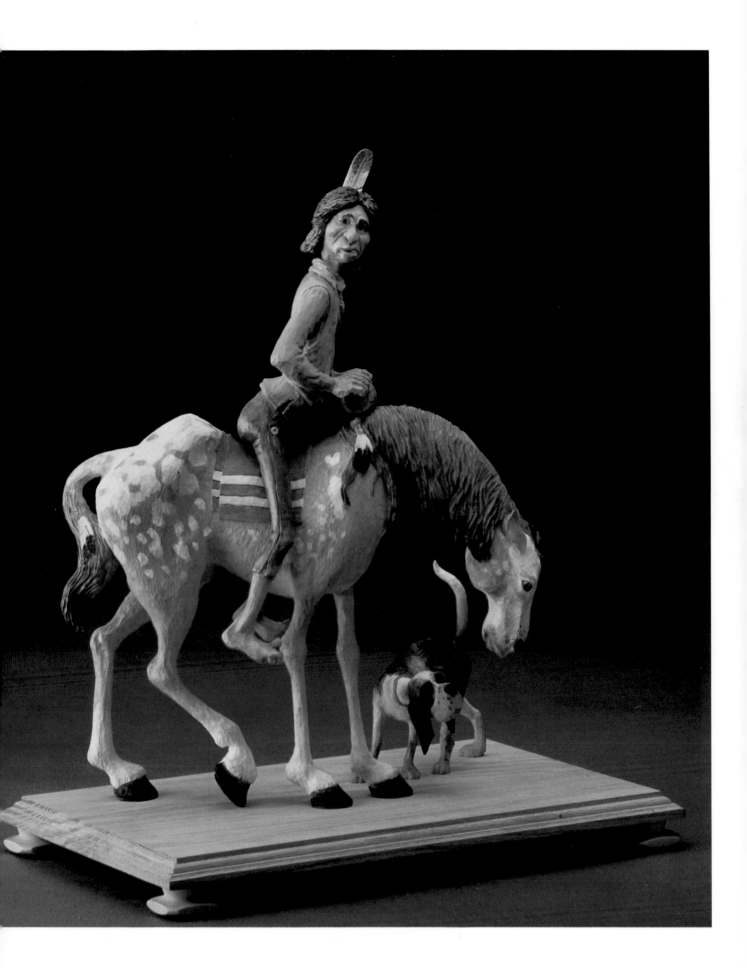

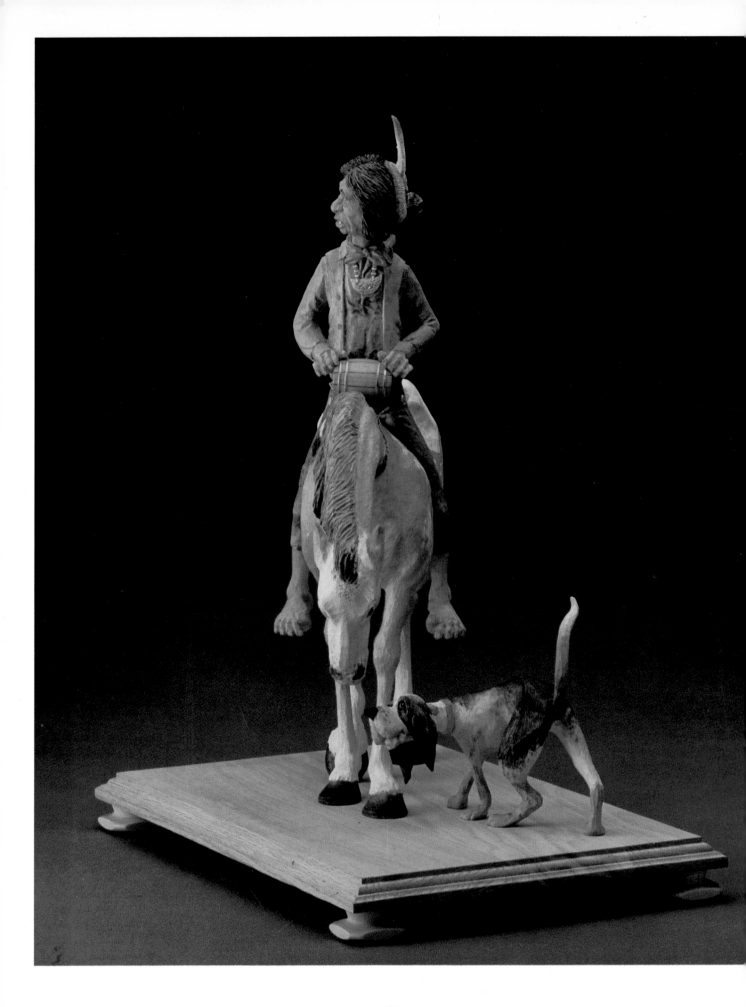

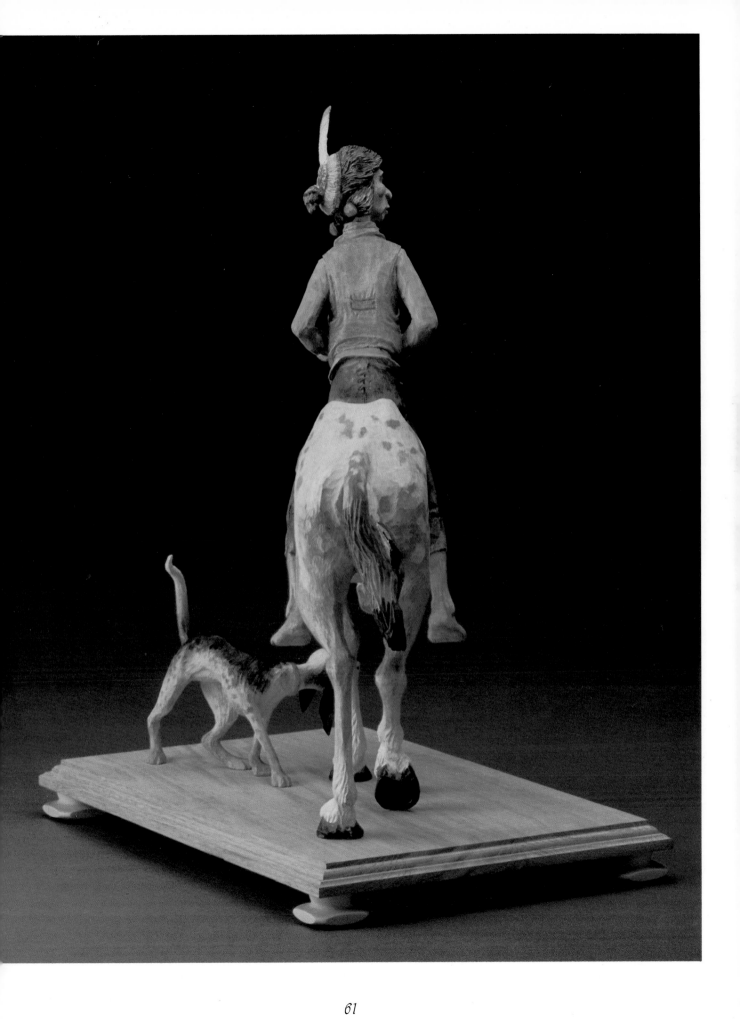

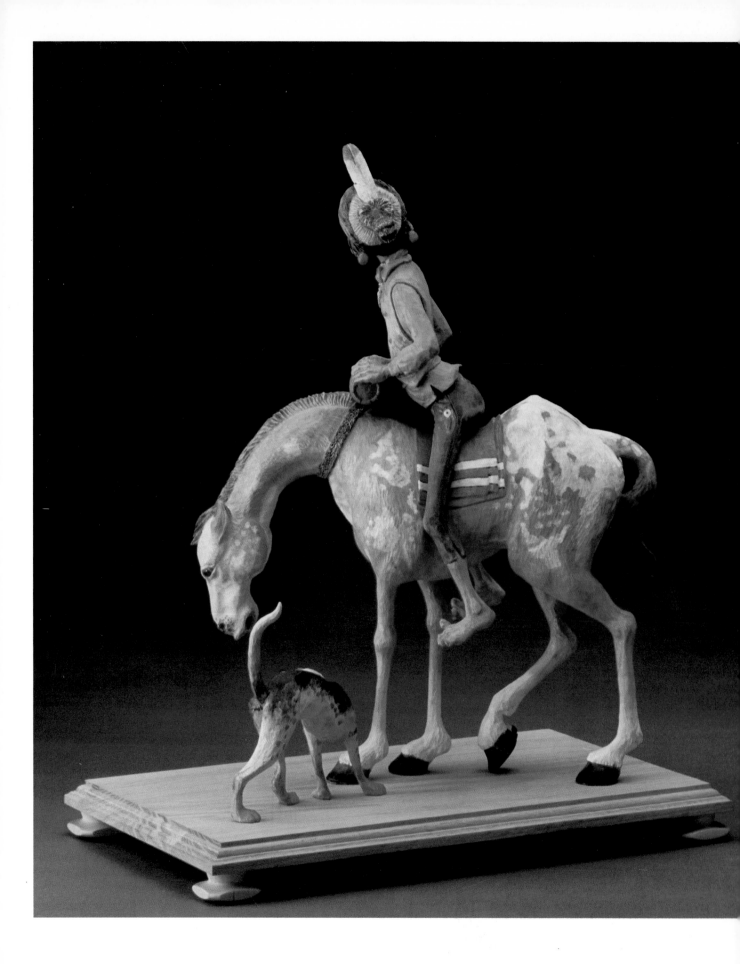

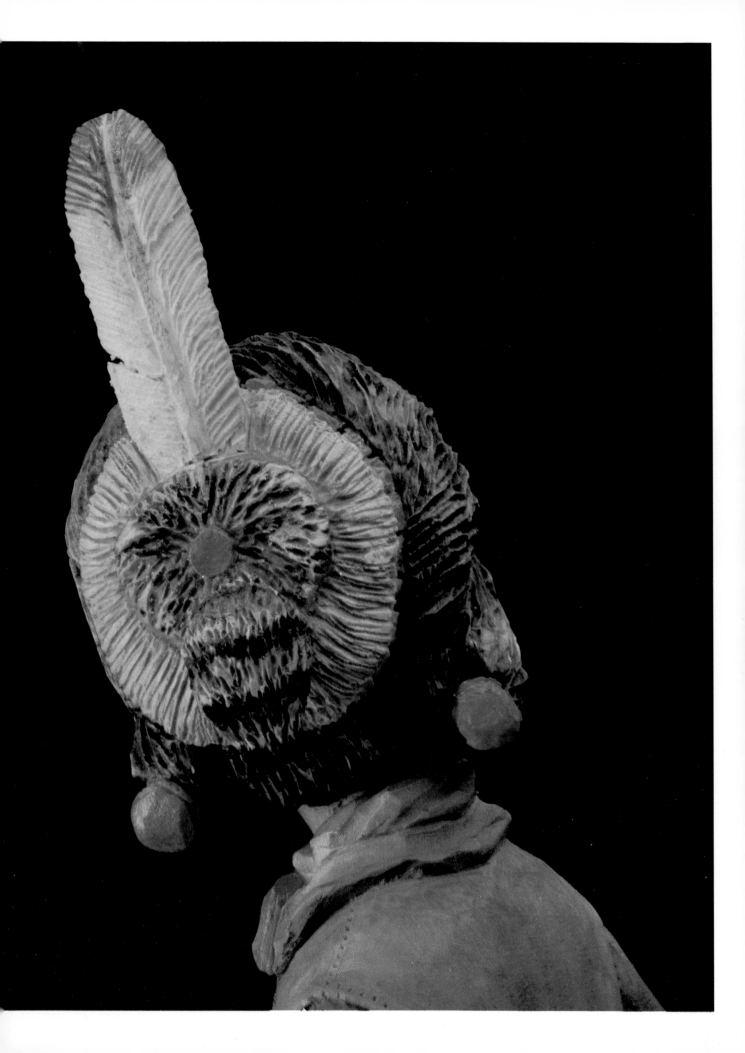

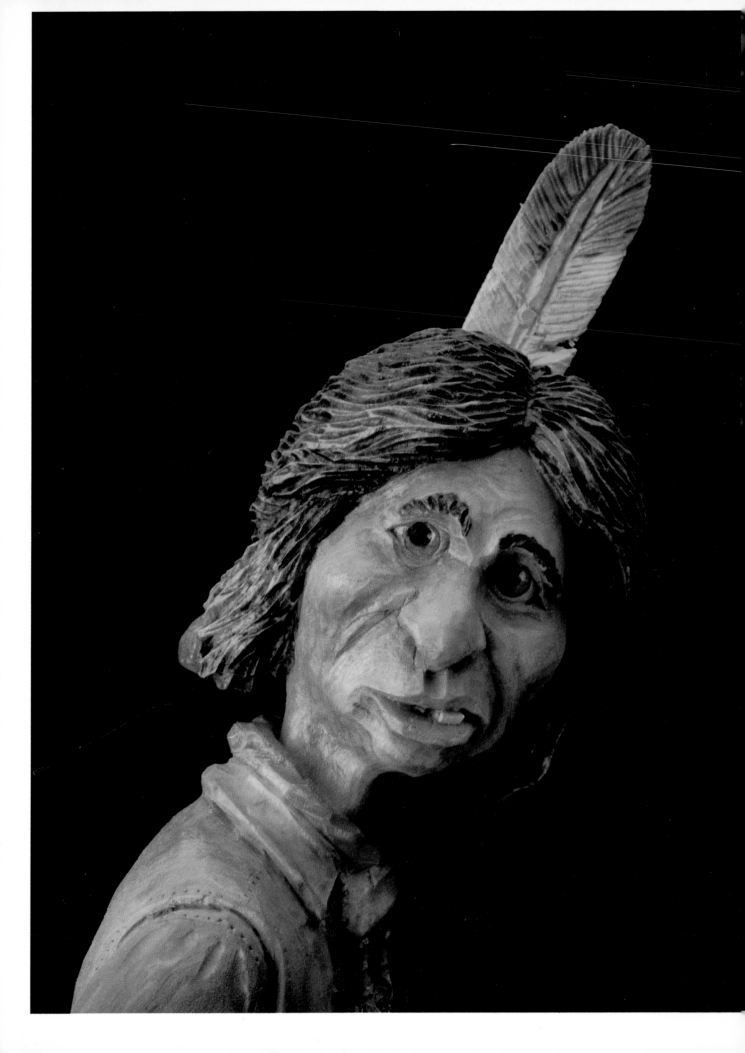